*Images of Modern America*

# OPRYLAND USA

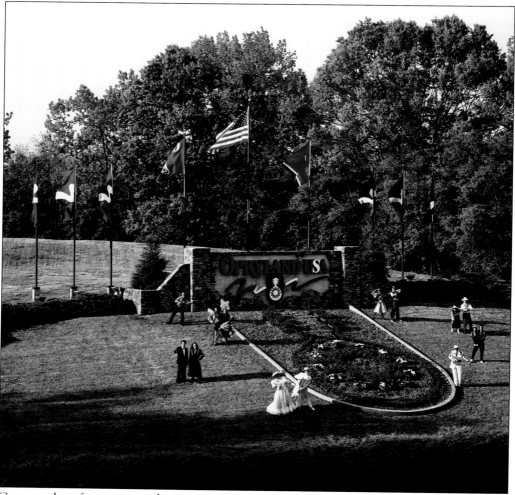

Cast members from various shows at Opryland USA gather around the manicured mandolin floral at the entrance to the complex. (Opry Entertainment.)

**FRONT COVER:** The Opryland Railroad rumbles through the Riverside area's kids' play zone, with its ball crawl, mountain climb, and Yachts of Fun attractions. (Opry Entertainment.)

**UPPER BACK COVER:** Porter Wagoner, as the official Opryland ambassador, and two friendly Opryland employees greet guests as they enter the front gate. (Opry Entertainment.)

**LOWER BACK COVER (from left to right):** *Me and My Gal* took guests back to the turn of the 1900s and the music of George M. Cohan's Broadway (Opryland Entertainment; see page 59), the Wabash Cannonball, named after the famous Roy Acuff song, was one of the first looping coasters of its kind (Opryland Entertainment; see page 60), the Flume Zoom, one of the original attractions, was always a park favorite (Michael Parham; see page 27)

*Images of Modern America*

# OPRYLAND USA

Stephen W. Phillips
Foreword by Ty Herndon

ARCADIA
PUBLISHING

Published by Arcadia Publishing
Charleston, South Carolina

Printed in the United States of America

Library of Congress Control Number: 2015953480

For all general information, please contact Arcadia Publishing:
Telephone 843-853-2070
Fax 843-853-0044
E-mail sales@arcadiapublishing.com
For customer service and orders:
Toll-Free 1-888-313-2665

Visit us on the Internet at www.arcadiapublishing.com

*To Mom and Nana, thanks for making me ride
roller coasters instead of playing baseball.*

# CONTENTS

# FOREWORD

I was a senior in high school from a small town in Alabama when I auditioned and got hired for the coveted job of performing at Opryland USA in Nashville, Tennessee. I actually missed my senior prom because we had five shows that Saturday, and I could not make it back in time. I did not regret it at all. I was having the time of my life. For a young wannabe performer, this was the ultimate chance of a lifetime. Working at Opryland USA gave me so many opportunities that I never would have dreamed possible.

My first time on the Grand Ole Opry happened because Roy Acuff came to one of our shows and invited me to be one of his guests on the Saturday matinee segment at the Opry. There were countless television appearances because of auditions that were constantly being held by the entertainment department of the theme park. I even landed a spot on the wildly popular television series *Star Search*, hosted by Ed McMahon. So many success stories came from this amazing place and time. Opryland launched the careers of many stars. It was a place where dreams came true. It was a place where families were entertained and made memories to cherish forever. It was also a place where kids like myself could dare to dream of being on those amazing stages one day. I got my start in country music because this magical place existed.

Every time I walk on the Grand Ole Opry stage, I still remember that emotional and very special performance was possible because I became a part of this amazing family called Opryland USA.

—Ty Herndon

# ACKNOWLEDGMENTS

The history of Opryland USA is as long and as twisty as the Screamin' Delta Demon. It would be almost impossible to present every Opryland ride, attraction, show, shop, or restaurant that ever existed in the park. Instead, the purpose of this book is to offer a brief glance at Opryland's history through images in an attempt to show the highlights that made this park such a memorable place for so many.

I would like to thank a number of people who assisted in the creation of this book. Without their help, this would never have been possible.

To those who helped directly with this project, I would like to thank Ty Herndon; Josh Williams; Michael Parham; Shane Connor; Chip Thomas; Amy Atkinson; Vicki Phillips; Phillip Robison; Chad Ravert; Kina S. Mallard, PhD; Denny Adcock; Matthew R. West; Brett Johnson; the Historic Amusement Foundation; Patrick Wentzel; Vernon Martin; Brenda Colladay; Karen Williams Leath; Emily Harris Brown; Alan Nelson; Kirk and Ronnee Ellithorpe; Craig Havinghurst; Caleb Pitle III; Gerald Crawford; Nick Archer; Ezra Van Damme; Josh Davis; Steve Spencer; Shawn Cook; Daryl Brown; Donna Roberson Nolan; Phillip Hostettler; Clay Stephens; Deborah Dorsey; Ken Kleespies; Rick Sweeney; Mike Rigsbee; Jackie Esposito; Alexandra Bainbridge; Rich Davis; and Sarah Padelford Carr, plus Lydia Rollins, Sarah Gottlieb, and everyone at Arcadia.

I am forever grateful for the inspiration and support from all of my former fellow employees at Gaylord Entertainment, as well as those currently employed with Ryman Hospitality and Marriott International. These extraordinary, creative individuals include, but are not limited to, Ed Stone, Dan Slayden, Beverly Dyer, Bob Whittaker, Rich Maradik, Suzanne Stephan, Michael McCamish, Bryce Callaway, Brenda Klausmann, Stephanie Audain, Adam Anghilante, Aaron Gumpenberger, Pam Chacko Huff, Andi Bordick, Katrina Maddox, Garth McDermott, David Beronja, Andy Gilchrist, Jenny Barker, Melissa McBride Gregory, Jared Jones, Chad Hunter, Jeff Zimmer, Dan Rogers, David Kloeppel, Tim Flors, Tammy Henry, Kristin Chenoweth, John Barrowman, and especially Tom Shukas.

This book would not have been possible without the support of family and friends that have endured my Opryland obsession for decades. Among those, but not limited to, are Rebecca Haithcoat; Phyllis Crawford; Jeff Crawford; Steven Murff; Bob T. Souder, MD; Polly Robison; Ken Barker; Heath Williams; Gavin Crawford; Kylee Crawford; Reese Robison; Garrett Robison; Cole Williams; Amber Williams; Julie Ann Williams; Jaxon Young; Curt Harrison; Judy Rogers Taylor; Fran Davis; Brenda Keller; Suzy Thompson; Christy Vermillion; Mary Valcarcel; Stephanie Lynn Mosley; Jim Schmidt; Joe Wooley; Austin Moylan; Kimberly Kaye; Jerald Skinner; Joy Bolton; Matt Totten; Eric Phillips; Susan Wheeler; Nancy Phillips Stephens; Charles Williams; Linda Mitchell; Preston Holland; Joshua Wagner; Matt N. Thomson; Jolie Seaborn Cripps; Annie Laurie Walters; and many, many others.

Unless otherwise noted, all images in this book are legacy copyright material from Opry Entertainment, the legal successor to National Life and Accident Insurance Company; NLT Corporation; WSM, Inc.; Opryland USA, Inc.; Gaylord Entertainment; and Ryman Hospitality and/or are licensed from the archives of Grand Ole Opry, LLC.

# INTRODUCTION

The Ryman Auditorium, constructed in 1892, is often referred to as the "Mother Church of Country Music," but by the late 1960s, after hundreds of nights of performances of the Grand Ole Opry, the weekly radio show had beaten the building into what its owners called "the mother of all firetraps." Without air-conditioning, the inside temperature could rise up to 120 degrees on summer nights. Some of the world-famous pews were supported by Coke crates. The outside of the auditorium was worse; adult theaters, panhandlers, and massage parlors lined the streets outside the Ryman. The thousands of families coming in to Nashville every weekend to see the Grand Ole Opry were appalled.

The Ryman would either have to be renovated, or a new facility would have to be built. Improvements to the theater did not seem practical since the attendance for the weekly shows continued to climb. The National Life and Accident Insurance Company was the corporate owner of the Grand Ole Opry, as well as WSM, the 50,000-watt AM radio station that broadcast the show each week. The final answer came when Irving Waugh, the president of WSM and the Opry, visited Houston, Texas, on a golf trip. There, he saw Judge Roy Hofheinz's Astrodome. It was the centerpiece of the Astrodomain complex, a property that not only included the Astrodome arena, but also the AstroWorld theme park, hotels, and more. Waugh had an epiphany. If the castle was Disney's icon at Disneyland on the West Coast and the Astrodome was the focal point for the Astro World resort, then a new Opry House could be a centerpiece for a similar venture.

No one had a theme park focused on music, and the Grand Ole Opry still had 325,000 people coming to Nashville each year to see the show and Opry House with nothing else to do. WSM veteran programmer Elmer Alley presented Irving Waugh a memo outlining his vision for the proposed Opryland resort. The new Opry House would have a theme park and a commercial district, mainly composed of hotels, motels, and apartments, that would complete the complex. On June 30, 1970, ground was broken for the Opryland USA theme park and future home of the Grand Ole Opry. The property encompassed 369 acres; 110 for the theme park, 105 for the future Opry Town, and the remaining acreage for parking and future development. Over the years, additional land around the property was purchased, and by 1997, the complex had grown to 750 acres.

One of the keys to Opryland's success was its location. Built just as Briley Parkway was extended past Interstate 40, the proposed land bordered the Cumberland River and was previously the site of Rudy's Farm, a sausage and bacon operation. Most of the land was undeveloped, full of trees, streams, and natural foundation. Randall Duell, the architect for the park, aimed to keep nature intact. His design for the park followed natural trails and preserved as much of the existing trees and nature as possible.

With an emphasis on live performances, nature, and the spirit of America, the $28 million Opryland USA theme park opened to the public on May 27, 1972. Only 8,000 people attended the first day; the second day, attendance dropped to just 3,500. However, by the end of the first year, Opryland topped its initial projection with an attendance of 1.4 million. By 1973, the park had found its footing, with the right blend of music, rides, and nature.

By 1974, the new Grand Ole Opry House was complete and the complex was almost intact. But as attendance at the Opryland USA theme park increased and the new Grand Ole Opry House regularly filled all 4,000 of its new seats, it became evident that the next phase of the Opryland master plan might need to be revised.

On November 27, 1977, the $25 million Opryland Hotel officially opened. Instead of solely catering to park and Opry guests, the Opryland Hotel became Tennessee's largest convention hotel with 600 rooms. An ingenious concept was developed by the Opryland Hotel general manager Jack Vaughn. On average, theme park and Opry travelers would stay at the hotel during the weekend, and conference and convention guests booked rooms during the week. It was a perfect formula, and when the hotel opened, it had already booked 600,000 room nights.

During the late 1970s, the park continued to grow, adding attractions and shows. Existing shows were updated each year to keep them fresh. A new area, State Fair, was built after the 1975 flood. But by the early 1980s, Opryland would experience a thrill ride of a different kind. The resort's corporate owners had been bought by American General, and the entire complex was put up for sale, either for whole or for parts.

After several companies expressed interest in the Opryland business units, a sale was finalized on September 1, 1983. The buyer was Gaylord Broadcasting of Dallas, a subsidiary of Oklahoma Publishing Company, a large publishing and multimedia conglomerate owned by Edward L. Gaylord. Opryland USA theme park, Opryland Productions, the Grand Ole Opry, Opryland Hotel, WSM-AM, WSM-FM, and the newly launched Nashville Network (TNN) were reorganized under a new umbrella subsidiary named Opryland USA, Inc.

The new Gaylord ownership left all existing management in place, with E.W. "Bud" Wendell remaining as president of Opryland USA, Inc. He was able to keep his job as top boss over the Opryland properties and stay in his office above the Roy Acuff Music Hall in the theme park.

Even though the ownership of the park was changing hands, the park had no intention of slowing down. Major attractions were being added every few years, such as the Screamin' Delta Demon and Grizzly River Rampage. After each new ride was built, attendance records would break. New shows were debuted every year. In addition, The Nashville Network started to produce daily talk shows, cooking shows, game shows, and concerts on the Opryland grounds, allowing park guests to watch or participate. In 1985, the *General Jackson* was launched, with even more shows and activities for guests to discover. Later, the Opryland Hotel began a long series of expansions and upgrades that brought new restaurants, shops, and more live music to the complex. In 1983, a total of 467 rooms were added along with a two-acre indoor Conservatory. Following Jack Vaughn's proven formula, along with the addition of the festive "A Country Christmas," the Opryland Hotel was an unqualified success. With the need for more hotel rooms and additional convention space, the resort quickly fast-tracked further expansion plans. In 1988, the hotel's Cascades expansion opened with 824 more rooms and two additional acres of indoor gardens under glass.

As the early 1990s dawned, the Opryland theme park was only one piece the company's fast-growing "country lifestyle" empire. In 1991, the Gaylord family decided to take the Opryland division public. Opryland USA, Inc. became the Gaylord Entertainment Company and began trading on the New York Stock Exchange. The company continued to aggressively expand with the purchase of Country Music Television (CMT) to compliment The Nashville Network's programming. On March 14, 1992, a second theme park, Fiesta Texas, described as a "destination market, musical show park," opened in San Antonio. Even though the park's ownership was mostly held by USAA, a diversified financial services group, Gaylord Entertainment designed, programmed, and managed the park and held minority ownership. In June 1994, after a $8.5 million renovation, Gaylord Entertainment reopened the Ryman Auditorium as a museum and performance hall. A few blocks away, the Wildhorse Saloon country music dance club opened, with three floors, sophisticated production facilities that regularly produced TNN series and specials, and the largest dance floor in the city. Sleek, new river taxis were added to the Opryland river fleet, ready to carry visitors and conventioneers from the resort all the way down to the new Opryland Dock, conveniently situated at Nashville's Riverfront Park, just steps away from the company's newly opened downtown properties.

By the 1990s, as Gaylord's entertainment portfolio continued to diversify, the Opryland Themepark  (as it came to be known) began to seem more like a mere seasonal draw on the books rather than the crown jewel it once was. Although the park continued to be comfortably profitable, even through its last year, the park was only open 9 to 10 months out of a year. As the success of Opryland Hotel began to overshadow the profitability of the park that spawned it, Gaylord Entertainment began to look at year-round recreational alternatives that would greater benefit the convention business of the hotel. Park attendance gradually dropped as the budget was spent on signing current and popular country acts to perform their touring shows in a new amphitheater specifically built for popular country acts. This expensive concert series, known

as "Nashville On-Stage," came at the expense of new rides or shows that would have been an investment in the park's entertainment roster and provided future enjoyment year after year. In early 1997, E.W. "Bud" Wendell retried and left the company in the hands of Terry London, Gaylord Entertainment's former CFO. By early summer, London was negotiating with the Mills Corporation on a proposed retail makeover of the theme park. The project, then known as Opryland Mills, would greatly affect the future of the Opryland USA theme park.

In the late 1990s, the Mills Corporation was a shopping center developer that had pioneered the concept of hybrid malls—indoor centers that combined off-price stores with traditional retailers, as well as a few select entertainment offerings. Marketing materials for theses shopping destinations stressed the "shoppertainment" experience that Mills visitors enjoyed at its malls. The initial plans for the Mills project appeared to resemble Universal CityWalk or DowntownDisney. When it was announced, the Opry Mills retail portion of the project was only one element of the entire complex's redevelopment and rebranding as Destination Opryland. The mall would be built on the existing parking lot for Opryland Themepark. In order to handle the increased attendance for the new development, one-third of the Opryland park would be cleared and converted into supplemental parking and access roads for the mall and other attractions around the resort. Encompassing the perimeter of the mall, large parking decks were to be constructed to handle the thousands of cars that would come to the complex every day to shop, eat, learn, and be entertained. The original plan for Opry Mills would connect the remaining two-thirds of the Opryland Themepark; a drastically renovated Grand Ole Opry with the addition of a portico designed for award show red carpet arrivals; a studio tour (similar to CNN's tour in Atlanta) at the TNN and CMT Broadcast Center beside the Opry House; and the new Cumberland Landing nighttime club district and dock for the *General Jackson*. In its original proposal, the Mills Corporation suggested to Gaylord Entertainment that as many existing theme park attractions as possible be kept.

However, when Opry Mills opened in 2000, no attractions were left from the former Opryland Themepark, no Broadcast Center, and no Cumberland Landing—the only thing remaining was the northern area of the park, once home to the State Fair and Grizzly Country, reserved for future attractions. Meanwhile, 110 acres of land across from the Opryland Hotel on Briley Parkway, once slated as the location of Nashville's Bass Pro Shop, was quietly annexed and rezoned. Both the former State Fair/Grizzly Country areas and the former Bass Pro Shop have been slated for attraction development since the park closed in 1997. In several instances, Gaylord Entertainment attempted to partner with various theme park operators to bring a theme park back to Nashville. Herschend Family Entertainment, the operators of Silver Dollar City and Dollywood, developed several themed concepts, including a new redeveloped Opryland park, complete with musical themed lands, exciting rides, and uplifting shows. Just as the project was about to be announced, the 2008 recession hit. Herschend and Gaylord tried to partner again in 2012—this time with Herschend's star ambassador, Dolly Parton. The two companies were pairing up to build the largest water park in the United States, complete with non-water attractions, shows, and winter activities to avoid the seasonality problem that plagued the original park. Herschend would manage the new park, and Gaylord Entertainment would provide the land, a large percentage of the construction and development costs, and the name *Opryland*. Unfortunately, that project fell apart, too, with Gaylord's decision to sell its hotel brand and partner with Marriott to manage the hotels.

In 2012, Gaylord Entertainment converted itself into a real estate company and changed its name to Ryman Hospitality. The company still owns the resort once known as the Opryland Hotel, as well as its four sister resorts. However, day-to-day operations for the hotels are now managed by Marriott International. Ryman Hospitality's entertainment brands are managed by its Opry Entertainment subsidiary. Those business units include the Grand Ole Opry, WSM-AM, the Ryman Auditorium, the Opry City Stage bar/restaurant in Times Square, and the company's percentage of the former *Nashville* television series on ABC. Since Ryman Hospitality is now primarily a real estate trust, it cannot hold on to these type of assets indefinitely. As of spring 2016, Ryman Hospitality is attempting to grow the entertainment division before spinning them off into its own company.

*One*

# A New Home for the Grand Ole Opry

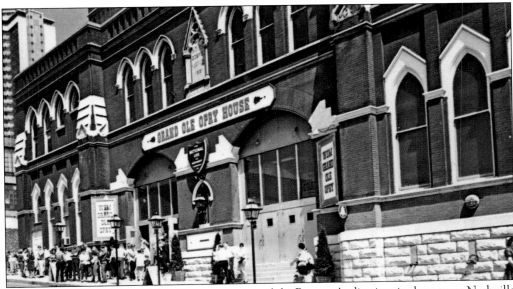

Lines of visitors to the Grand Ole Opry queue around the Ryman Auditorium in downtown Nashville during the 1960s. The show's growing popularity, combined with the building's dilapidated state and the seedy nature of the downtown neighborhood of the day, prompted the show's owners, National Life and Accident Insurance Company, to look at options for the future of the historic radio program.

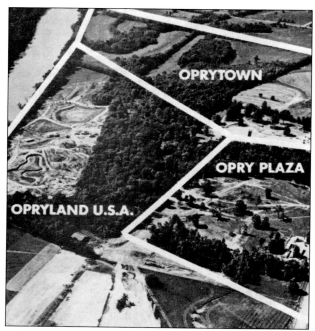

OPRYTOWN

OPRY PLAZA

OPRYLAND U.S.A.

WSM president Irving Waugh had witnessed the success happening in Houston with the city's new stadium. The Astrodome had recently been constructed; however, it was the attached theme park that was keeping visitors coming. Waugh thought the same thing could work with the Grand Ole Opry. A theme park attached to the two-day-a-week show could help pay for a new venue for the Opry. The "Oprytown" area marked on the map was a planned commercial district that would evolve into the Opryland Motel and eventually into the Opryland Hotel Resort and Convention Center. Decades later, the Oprytown idea would resurface as an (abandoned) concept to connect the Grand Ole Opry House to the hotel. (CSR.)

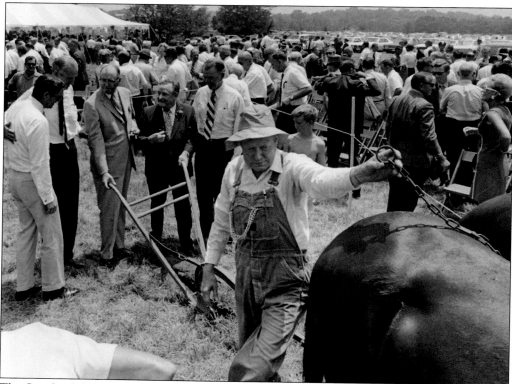

The Opryland theme park did not have a traditional ground breaking. In a setting that was fitting of the Grand Ole Opry's roots, future Opry member Bashful Brother Oswald (also known as Pete Kirby) used a mule plow for the ground breaking of Opryland on June 30, 1970.

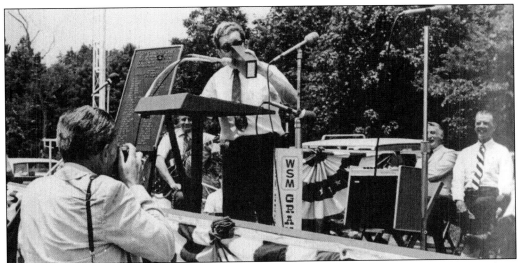

During the ground-breaking ceremonies on June 30, 1970, Roy Acuff blew the same steamboat whistle George D. Hay used to start every Opry performance. Hay was the first to use the term "Grand Ole Opry." On December 10, 1927, WSM's Barn Dance program followed the NBC Music Appreciation Hour, a program of classical music and selections from Grand Opera. Hay said, "For the past hour, we have been listening to music taken largely from Grand Opera. From now on, we will present the 'Grand Ole Opry.'" As of 2016, the same whistle is on display backstage at the Grand Ole Opry House and visible on public tours. One of the highlights of the Opryland USA ground breaking was the attendance of Elizabeth Craig, the widow of Edwin Craig, the former chairman of the board of National Life and Accident Insurance Company. Edwin Craig spearheaded the development of WSM and the Grand Ole Opry. In the photograph below, Irving Waugh thanks Elizabeth Craig. (Both, TENN.)

After an exhaustive search for a feasible site, 369 acres were purchased from Rudy's Farm, a sausage manufacturer located along the newly constructed Briley Parkway, 10 minutes from downtown Nashville. Transforming the rural Pennington Bend site into an entertainment theme park cost an estimated $28 million. (Author's collection.)

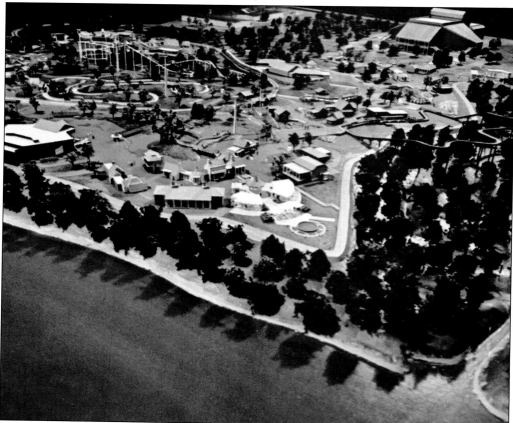

This Opryland USA theme park scale model displays most of the opening day attractions, including the Timber Topper, Flume Zoom, American Music Theatre, and Tin Lizzies. The Grand Ole Opry, which was not scheduled to open until a later date, is still featured on the model.

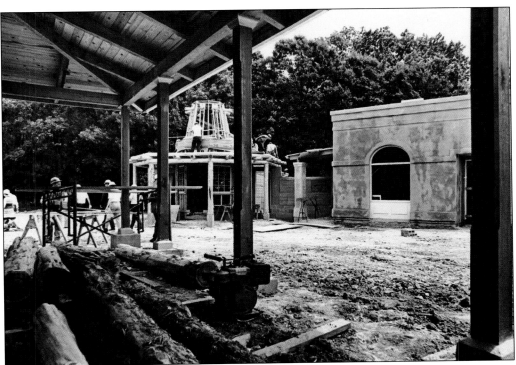

Construction progresses in the American West area as workers build a replica of an 1870s town during the 1970s. Park designers were careful to use the natural environment to enhance the artificial landscapes that they were creating. Sidewalks were built to follow natural pathways. Streams and waterfalls were built to compliment natural surroundings. Gardens were planted to follow the natural curve of the terrain. (TENN.)

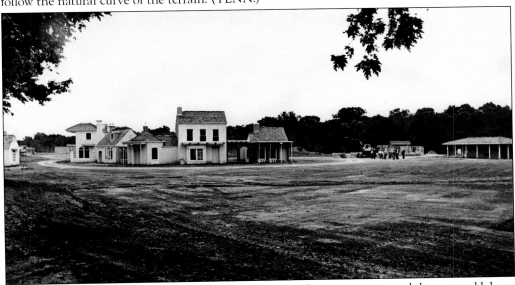

Buildings in the New Orleans area near completion as workers progress around the carousel lake to start work on other structures in the Hill Country of Opryland USA. These buildings were erected full-scale, opposed to the forced-perspective technique used at similar theme parks. (TENN.)

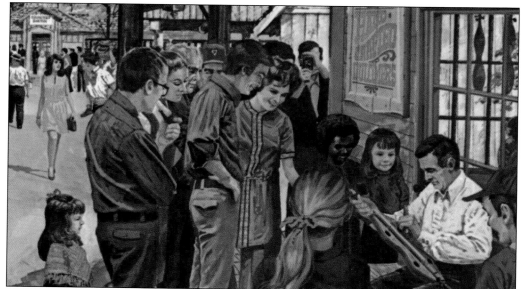

Original concept art shows the arts and crafts vendors in the Hill Country area of the park. When Opryland was originally under development, the themed lands were to be Little Ole New York (with the music of Broadway), the Old West, Dixieland, Old Mexico, and Haight-Ashbury (dedicated to what the 1960s counterculture referred to as the "Scene").

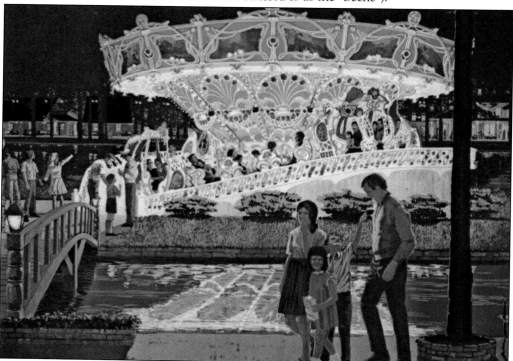

Randall Duell and Associates of Santa Monica, California, designed Opryland USA. The firm had previously designed other theme parks, including Marriott's Great America and the original Universal Studios Tour, as well as several pavilions at the 1964–1965 New York World's Fair.

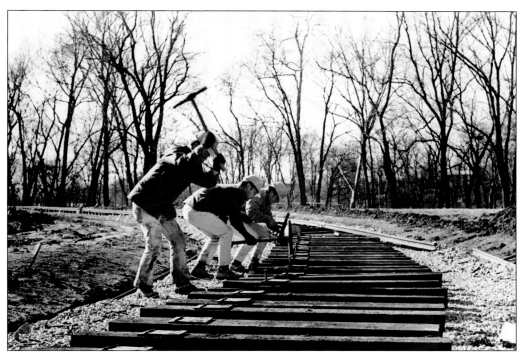

Workers lay ties and rails for Opryland Railroad. The park opened with two engines and two stations. One of the depots was named for the "El Paso" song by Marty Robbins and the other named Grinder's Switch, for the fictional hometown of Grand Ole Opry star Minnie Pearl. (Both, TENN.)

Irving Waugh looks over his park just before opening. He once said, "We have 325,000 people to see the Opry every year. They come in town with time on their hands and nothing to do. We can't build a new Opry House for just a few performances a week. So, why don't we go out in the countryside, buy ourselves a few acres, build a new theater for the Opry, and surround it with an entertainment park?" After the project was announced to the public during the 1968 Grand Ole Opry birthday celebration, the National Life and Accident Insurance Company Board of Directors officially voted to build the park in September 1969. Originally estimated to cost $16 million, the park's final price tag came to a total of $28 million.

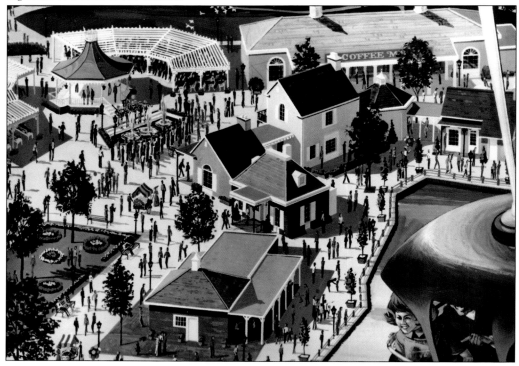

# Two

# THE HOME OF
# AMERICAN MUSIC

**The new Opry is still on the drawing board and already we're drawing a crowd.**

Opryland, our 25 million dollar vote of confidence in the home-grown music of America, doesn't open until 1972 ... and already people are after reservations for opening night.

Tells you something about the Opry, its people and its music, doesn't it?

But Opryland doesn't begin and end with just the Opry. There are museums, amusements, restaurants, intimate and interesting little corners of music native to the rivers, the mountains and the Great American West.

And the Opry House itself is something else. Designed for the future of country music, conceived to make audience and artist seem almost as one, the new Opry will boast radio and television production capabilities the likes of which you'll be hard put to find anywhere.

If we sound a little proud of Opryland, it's because we are.

And we'll be more than a little surprised, in 1972, if you and those people looking for opening night reservations aren't just as proud.

**WSM INC.**
An affiliate of NLT Corporation.

WSM never passed on a chance to promote itself. Although the park was years away from opening, WSM took out a full-page advertisement to attract attention to both Opryland and the new Grand Ole Opry House.

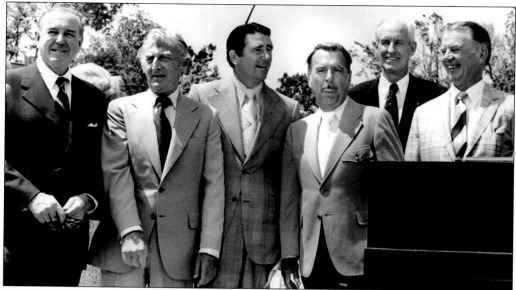

On May 21, 1972, an estimated 3,500 invited VIPs gathered on Opryland USA's 30-acre parking lot to hear 45 minutes of speeches to dedicate the complex before a sea of red, white, and blue balloons filled the air high above the Cumberland River. Dignitaries at the event included Tennessee governor Winfield Dunn, Congressman Richard Fulton, and Nashville mayor Beverly Briley. The special soft opening of the park was only for Opryland's corporate parents, WSM, Inc. and the National Life and Accident Insurance Company; the media; and government officials. G. Daniel Brooks, chairman of the board of WSM, told the audience that Opryland USA was the end result of company history that started 47 years ago when "Uncle Jimmy" Thompson sat down with his fiddle in front of WSM's microphone. By the time the sun set, officials estimated that 12,000 visitors had entered the park. One week later, the park would officially open to the public at 10:00 a.m. on May 27, 1972. (TENN.)

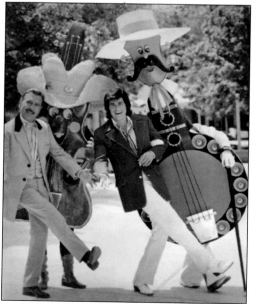

The grand opening of the park was planned be a giant media event, similar to the openings of Disneyland and Walt Disney World, including a prime-time network special that showcased the park for the nation. *Timex presents Opryland USA* aired May 30 on NBC, three days after the official opening of the park. Hosted by Johnny Cash and Tennessee Ernie Ford, with special guests such as Danny Thomas and Minnie Pearl, the program highlighted the park's entertainment, ranging from country to pop. Prime-time network specials continued to showcase the park until 1996.

Since approximately 25 percent of the park existed in the deep woods, it was decided early on that the park's maples, oaks, pines, cypresses, and dogwoods would be a strength rather than a hindrance. Two giant tree-moving machines worked 15 hours a day to transplant 4,000 existing trees. According to Mike Downs, the park's first general manager, almost 100 percent of the original trees on property were saved.

Ben Moore, the park's landscape manager, developed a temporary tree nursery, complete with existing bird nests, to add plant life to the complex. There were 400 additional dogwood and magnolia trees to mingle with the natural tulip poplar, honey locust, black cherry, and sweet gum trees.

In the first year, there were 18 seasonal and 9 permanent employees hired solely to tend to the flowers and plants, as well as the five acres of lawn grass. In addition to the multitude of trees, 1,000 hanging baskets were mounted, 150 whiskey barrels were arranged, 100,000 annuals were placed, 1,000 bushes were set, and 1,200 tulips were planted. As seasons changed during the operating year, 20,000 flowering plants would rotate in as the year progressed.

Upon entering the Opryland USA complex, one would have been immediately surrounded by the antebellum-inspired architecture of Opry Plaza. The area was free to the public, open year-round, and full of museums, ticket booths, gift shops, food stalls, and, by 1974, the Grand Ole Opry House.

One of the first attractions announced for Opryland was the Roy Acuff Music Hall. Acuff had previously owned a similar attraction near the Ryman Auditorium in downtown Nashville. Acuff had saved memorabilia throughout his rise to fame and collected rare mementos from other celebrities as well. Included in the attraction were artifacts such as the fiddle that Acuff used to record his number-one hits like "Wabash Cannonball" and "The Great Speckled Bird." Other instruments included Mother Maybelle Carter's autoharp and Little Jimmy Dickens's guitar. The museum's prized piece was Uncle Jimmy Thompson's fiddle, which was played on the first radio broadcast of the Grand Ole Opry. Years later, Minnie Pearl opened a similar museum. Even later, Roy Acuff and Minnie Pearl shared a larger museum together in the former Southern Living model home.

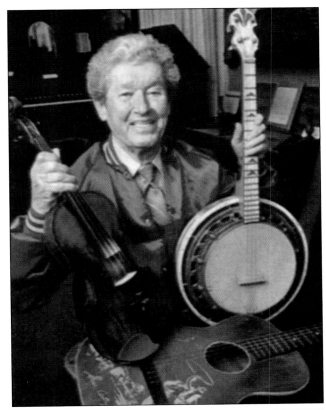

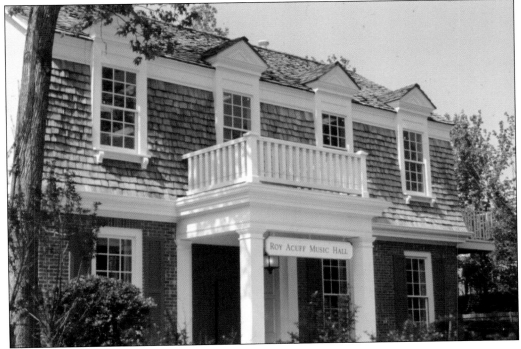

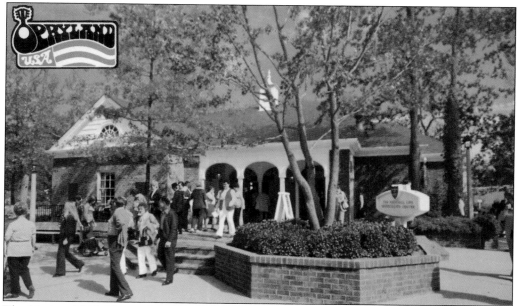

The National Life Hospitality Center in Opry Plaza served as both guest relations for visitors and as a theater venue for the 20-minute "Great Moments from the Opry." The multimedia show highlighted America's country music heritage. Guests could also obtain information about handicap-accessible shows and rides, check a park-wide message board, upgrade tickets to a season pass, exchange Canadian currency, and check for lost and found articles.

After entering the turnstiles, the first area to the left was Hill Country. In its initial years, it was also known as Appalachian Village or the Folk Music area. However, the theme remained consistent—visitors could see real craftsmen at work; enjoy real authentic country food, such as biscuits and molasses; and listen to the roots of country music. Additionally, the park's first breakout ride, the Flume Zoom, called this area home. (Author's collection.)

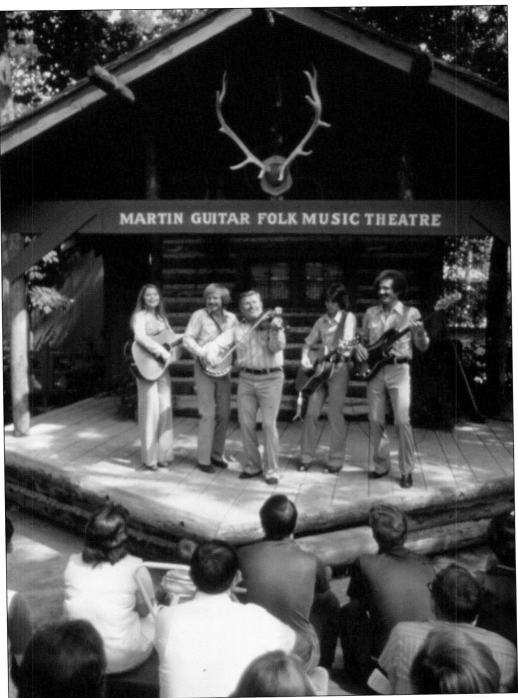

Originally sponsored by Martha White flour, the C.F. Martin Guitar Folk Music Theatre featured several recording artists, such as Mack Magaha and Russ and Becky Jeffers. The 425-seat amphitheater came alive with down-home sounds of bluegrass and mountain music. The pickin' and singin' seemed as natural as the outdoor theater's rustic benches.

By the 1990s, the park's focus had shifted to the visitors' desire to meet the stars and celebrities of country music. The Hill Country area was renamed Opry Village, and Grand Ole Opry stars were made available for autographs and pictures every day the park was open. More importantly, the celebrities could now participate in daily shows at the Martin Guitar Folk Music Theatre.

In Hill Country, Opryland visitors could see a real potter working away at a potter's wheel, a woodworker's bench and loom, candle-making demonstrations, or a craftsman making musical instruments for sale. Other trades on display included carvers, glass engravers, and sign makers. Elsewhere in the area, WSM-AM had broadcast facilities that produced a weekly show from the park. Years later, both WSM-AM and WSM-FM would move their entire facilities to the theme park.

Opryland's Flume Zoom captivated the imagination of its guests from opening day. Designed by Arrow Development, the attraction was similar to the log flumes used by lumberjacks to move their logs from the hillsides to the river. Unlike similar log flumes that floated at ground level at other theme parks, Opryland's flume was almost entirely 75 feet in the air. Eight pumps propelled 28,000 gallons of water per minute through the flume and then down the 90-degree drop. In 1979, as part of a sponsorship agreement, the attraction was renamed the Nestea Plunge. After the promotion ended, the Flume Zoom title returned for a few years until the ride was christened Dulcimer Splash in the 1990s. The flume was slightly altered in 1984 to accommodate the Screamin' Delta Demon, which had its track built around the ride supports and surroundings. (Both, Michael Parham.)

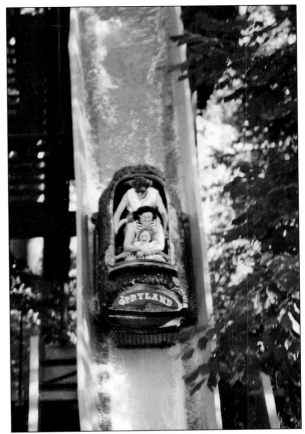

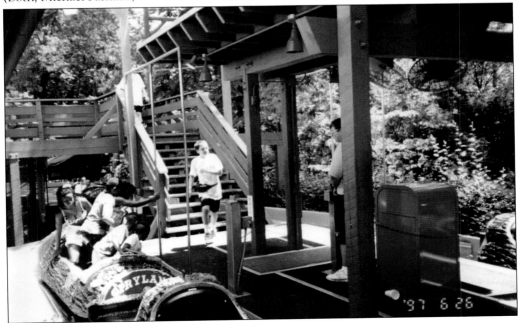

The Opryland Railroad was a loop of a three-foot gauge track that connected two stations, El Paso and Grinders Switch, inside the park. The total length of the railroad was slightly less than a mile. During the park's first years, the railroad consisted of two authentic steam trains. The trains ran daily with either one or both trains, depending upon attendance. The original cast-iron sign from the real Grinders Switch, home of Minnie Pearl, located near Centerville, Tennessee, was placed near the front of the station. (Michael Parham.)

There were two stations for the Opryland Railroad: Grinders Switch and El Paso. Both stations were of similar design with a central enclosed office area that led to open-air covered waiting area on each side. The El Paso station was situated in the American West; whereas, the Grinders Switch station was located in the Hill Country.

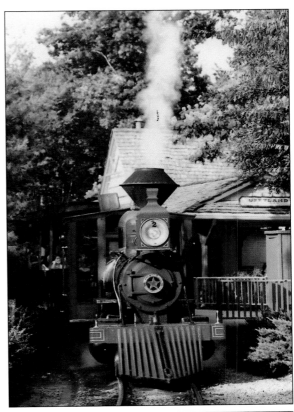

As attendance climbed, Opryland Railroad's stock grew to three locomotives: *Beatrice* (No. 1, later renumbered to No. 4 after diesel conversion), *Rachel* (No. 2), and *Elizabeth* (No. 3). *Beatrice*, a steam-powered locomotive, was later converted to a diesel/hydraulic engine in the park's later years. *Rachel* was a steam locomotive as well, but *Elizabeth* was an original train built especially for Opryland. She had a diesel/hydraulic engine replica that had the outline of a steam engine and resembled the park's other two trains. (Both, Michael Parham.)

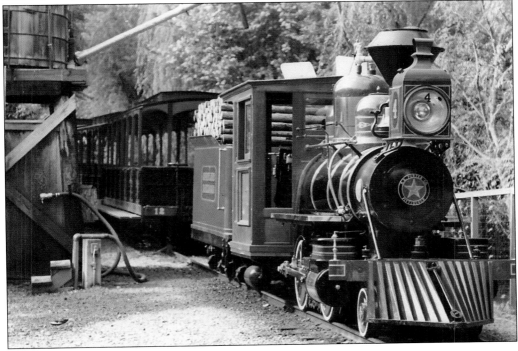

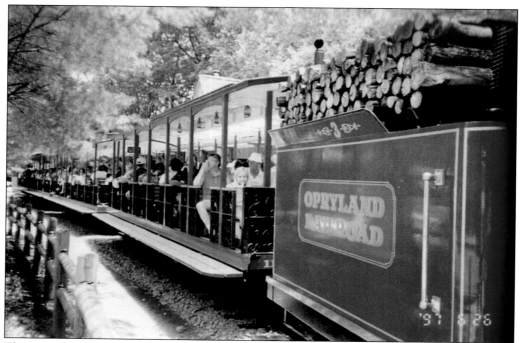

There were eight coaches, each having seats that faced both directions. Two of the coaches were designated as end units, with an elevated seat for the rear train host. All three locomotives had decorative "loads" of wood visible to imply that they were wood-burning steamers.

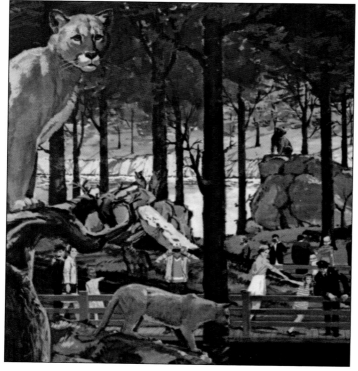

Unlike other parks with singing animatronic animals, early Opryland press materials stressed the real, live nature of the new park. The Animal Ravine was a short lived attraction that debuted with the park and led visitors along a wooded area bordered by the Cumberland River. Visitors could walk through the area on paths that created the impression of being surrounded by animals. The attraction was designed by Jim Fowler of television's *Wild Kingdom*. More than 500 animals were in the ravine in 1972, including lions, bears, wolves, buffalo, beavers, and other animals in their natural habitat.

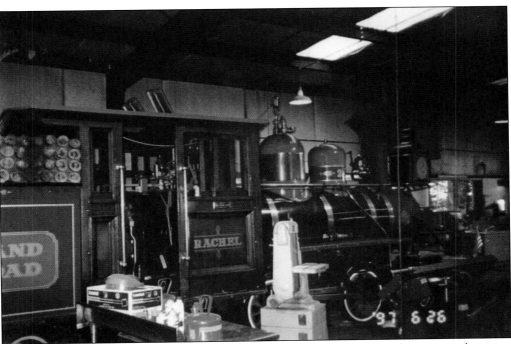

The Opryland Railroad had its own dedicated maintenance building, with a two-track engine house that consisted of a rectangular green metal structure with roll-up doors on each end. The dead-end tracks inside the engine house featured pits below the tracks that allowed for working on the underside of the engines and coaches. In 1980, the track closest to the main line was extended past the end of the engine house in order to assist the conversion of *Beatrice* from steam to diesel. Fueling the locomotives was done along the main track instead of the engine house. All engines used No. 2 diesel fuel, and an elevated water tank provided treated water for boiler use.

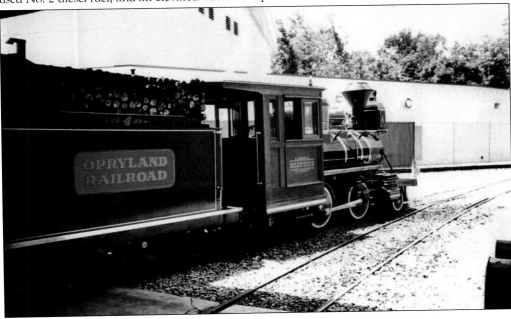

Right around the corner of Hill Country was the New Orleans area. With 12 structures, New Orleans had the most buildings of any of the lands when the park opened. There was coffee brewing and Cajun specialties cooking. The grilled ironwork dripped like black lace from a French Quarter balcony. There was also a Dixieland show, a flower mart, an artist alley, a glassblower, and a magic shop.

"American music is real as the blisters on a man's hand behind a blow," said Mike Downs, Opryland's first general manager. The architecture in the park, especially in the New Orleans area, strived to achieve that realness. The buildings used bricks, cedar shingles, and whitewash instead of fiberglass, steel, and theatrical set paint found at similar theme parks.

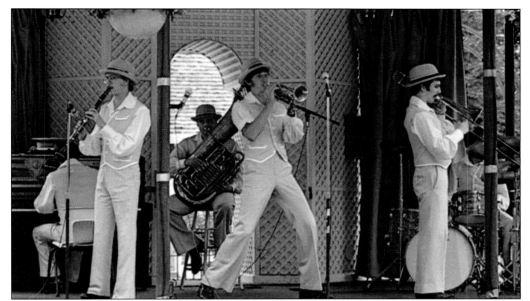

The Dixieland Patio theater served as the centerpiece for the New Orleans area. Several shows called it home, including *New Orleans Jazz*. It featured the sounds of Scott Joplin, Louis Armstrong, and other Dixieland greats who gave America its own special kind of music. From Dixieland jazz to rhythm and blues, the *New Orleans Jazz* show made visitors smile, clap their hands, and tap their feet.

The Riverside area contained both Opryland's original signature show as well as its signature ride. While other areas of the park were designed to highlight specific areas of American music, Riverside celebrated American music as a whole with a fabulous Broadway musical revue entitled *I Hear America Singing*. The show was performed across from the park's original antique carousel, which included gondola-like ride vehicles that appeared as decorative fairyland carriages built from ornate German wood.

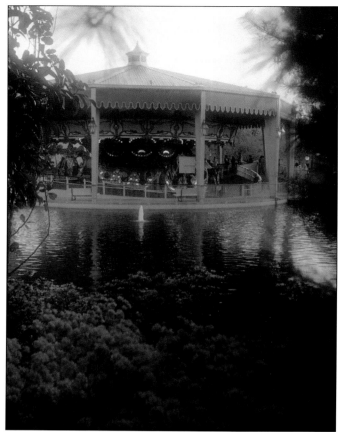

For many years, Opryland's antique carousel was the centerpiece for most of the parks advertisements and promotions. Contrary to what early marketing materials claimed, the attraction was not built in the 1800s but created around 1905 by ride designer Hugo Hasse Borg und Talbahn. The ride was built from wood gathered from the Black Forest of Germany. The attraction, with its eight gondolas, first operated in Copenhagen before going into storage for nearly 50 years. Pete Logan, from Showcrafts, Inc. of Miami, found the ride for Opryland, refurbished it, and installed the attraction on its own island in the park. When Logan first found the ride in Copenhagen, it was in 5,000 unmarked pieces, weighing 50,000 pounds, with only a faded picture postcard to guide the installation.

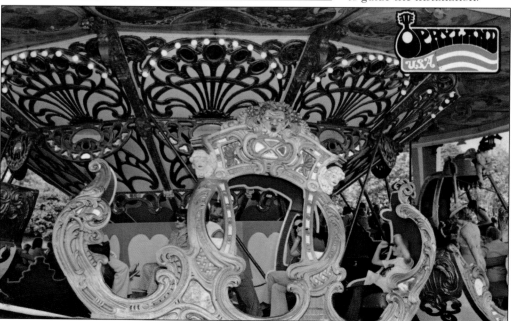

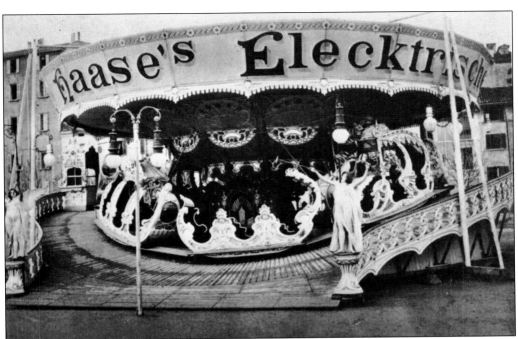

This is how Opryland's original carousel appeared in the early 1900s at a fairground in Europe. The term "carousel" is not quite the correct classification for the attraction. Having no horses or animals, the ride was technically defined as a "circular switchback." A huge success in Europe, these slow-moving attractions allowed the public an opportunity to enjoy luxury that was in sharp contrast to their lives.

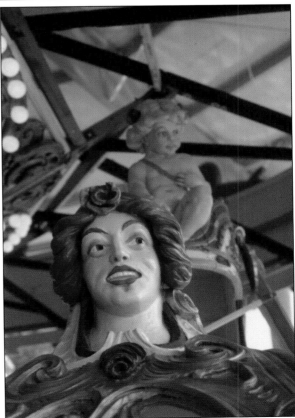

The details of the antique carousel were true works of art. Each of the eight gondolas were adorned with ornate women, babies, cherubs, and bats—all German good luck symbols that were hand-painted to enhance the detail of the original art. In addition, the ceiling panels of the attraction were delicate original oil paintings on canvas. (Author's collection.)

The only production that was staged during both Opryland's opening and closing year (though not continuously) was the park's flagship musical *I Hear America Singing*. The musical journey through 100 years of American history featured a live 12-piece orchestra and an 18-member cast. The production was originally slated to be the nighttime finale to the park's operating day. However, it was feared that the music would drift over the Cumberland River and disrupt nearby residential areas. Consequently, the park's first indoor, air-conditioned theater was built: the American Music Theatre. The show's song selection would vary slightly each year; however the bulk of the show would remain the same, with a few current songs added to the set list. Consequently, the running time of the show would fluctuate. A completely revamped version of the show, entitled *I Hear America Singing Its Song*, was staged for a single year in 1985 in the Encore Theatre (the former Showboat Theatre). The original title and themes would return to the American Music Theatre in 1995.

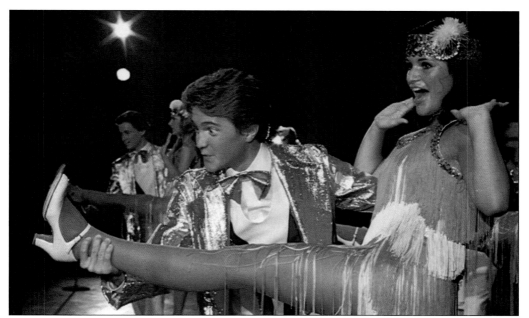

Paul Crabtree, original writer of *I Hear America Singing*, says that the show was "full of salutin', recruitin', and disputin' songs. It's music that reflects what happened to us socially and culturally through the impact of war, the miseries of depression, the jubilation of happier times, and the feelings and reactions of people to events across the years." The show had several cast recordings and was even staged during halftime at the 1981 Orange Bowl in Miami.

The American West area of Opryland was built to be reminiscent of El Paso, Texas, in the 1880s, complete with a cantina, a blacksmith, and a general store. However, instead of desperadoes gunning each other down in the street, there were "sing-outs," as strolling bands and the Opryland characters roamed around the area entertaining visitors with impromptu shows.

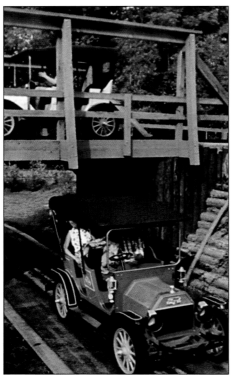

The Tin Lizzies attraction allowed one driver and up to three passengers to cruise along in a gasoline-powered 1911 Model T. The Tin Lizzie automobiles traveled at five miles per hour along a winding, overlapping, 1,200-foot roadway. A central guide rail in each lane ensured that motorists remained on the road.

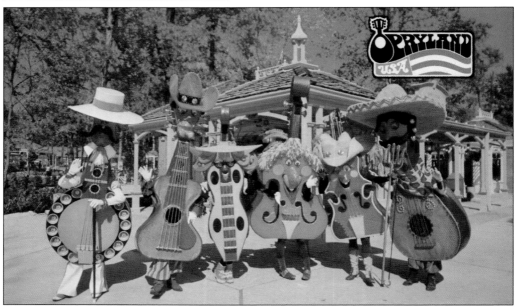

The ambassadors for the park during the early years were six original larger-than-life musical instruments that roamed the grounds, especially the American West area. The costumes weighed 40 to 90 pounds each and could be up to nine feet tall. From left to right are Yancy Banjo, Johnny Guitar, Delilah Dulcimer, Barney Bass, Frankie Fiddle, and Jose Mandolin. The characters appeared on everything from coloring books to collector plates.

One of the grander shows envisioned for the park was the "American Horse Pageant," a theatrical horse celebration about how horses were used to shape America. A large horse arena with a 1,000-seat stadium was built, and the Loretta Lynn Rodeo was recruited to perform in the show as Indians, trappers, pony soldiers, Pony Express riders, and cowboys. Unfortunately, when it rained, the arena turned into a giant mud puddle. The crowds did not seem to take to the show (and neither did the horses). During the park's second operating year, the horses were sent home, and the arena became the Showboat Theatre.

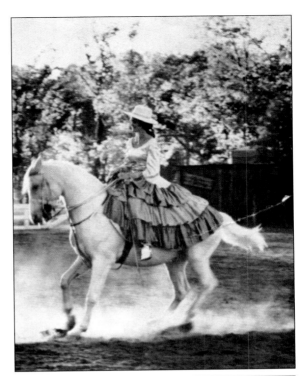

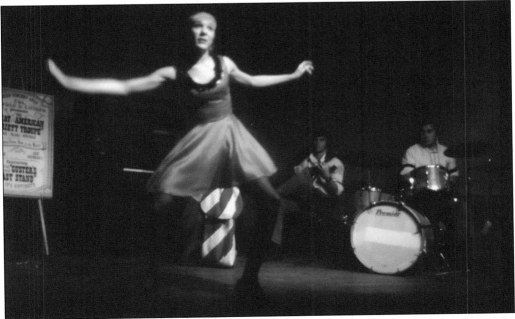

At the La Cantina Theatre, eight young musicians/artists presented an improv review to an audience relaxing at café tables and around the stage. The opening show, entitled *They Went That-A-Way*, featured song, dance, comedy, and lots of give-and-take between the audience and entertainers. The venue changed names several times before becoming an arcade and, ultimately, the Opry Sound Studio, where visitors could record their own song on tape.

Also called Ryman's Ferry, the Raft Ride allowed visitors to experience a relaxing journey aboard a four-person, battery-powered craft built to resemble a wooden flatboat of yesteryear. Eagle Lake was the staging area for this attraction, with stumps and trees dangling with moss that surrounded visitors as they passed by an old shanty boat.

The Lakeside area got its name from the three-acre body of water that dominated that territory of the park. Originally designated Lake Cumberland during the design phase, the lagoon was later called Eagle Lake once the park opened. (Author's collection.)

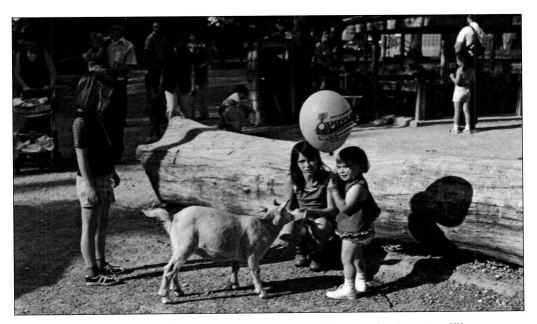

When the park first opened, there were two petting zoos. One near the American West area was set aside for farm animals, such as ducks, geese, lambs, goats, and pigs. The other animal petting attraction was near Opry Plaza and specifically for wild animals, such as deer and raccoons. Opryland animal specialists chose the park's animals based on their gentleness.

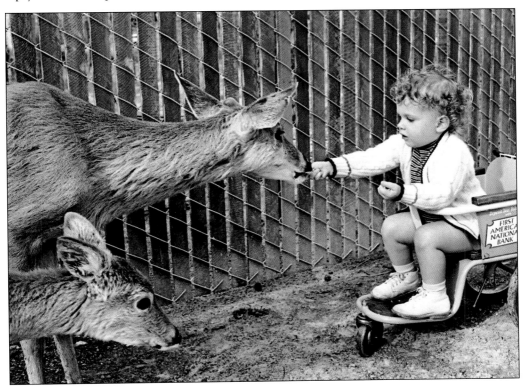

The Music of Today, or "Mod," area was designed to highlight the changing scene of music occurring during the 1970s. Even the architecture of the shops and restaurants had a mod flavor, with varying angles and alternating colors. Shows such as the "Opryland Rock Show" used the roofs of buildings in the area as stages, such as the canopy above the ice-cream parlor and pizza parlor.

The Music of Today section reverberated to the melodies of "Old Aunt Mary," an antique, Belgian calliope built in 1920 that operated as if it were a 70-piece band, replicating the sounds of winds, strings, and percussion. It was programmed to play more than 100 arrangements, from the "William Tell Overture" to "Aquarius." Unfortunately, it was destroyed during the 1975 flood that pushed the Cumberland River over its protective flood wall and into the park.

The Skyride was a cable-car ride manufactured by Von Roll and featured two stations, one in New Orleans and the other in the Music of Today area (later Do Wah Ditty City). The stations were 1,139 feet apart. Unlike similar rides at other parks, both stations were at ground level. The Skyride allowed guests to quickly travel across the park while getting an aerial view of most attractions. There were four towers to support the Skyride at approximately 220-foot intervals. There were two 85-foot main center towers in the middle of the cable route and two 65-foot towers near each station. There were a total of 40 numbered cars. Initially, red cars had even numbers, and blue cars had odd numbers. The exception was No. 40, which was painted orange. In later years, the color pattern changed, and some of the cars were randomly repainted green.

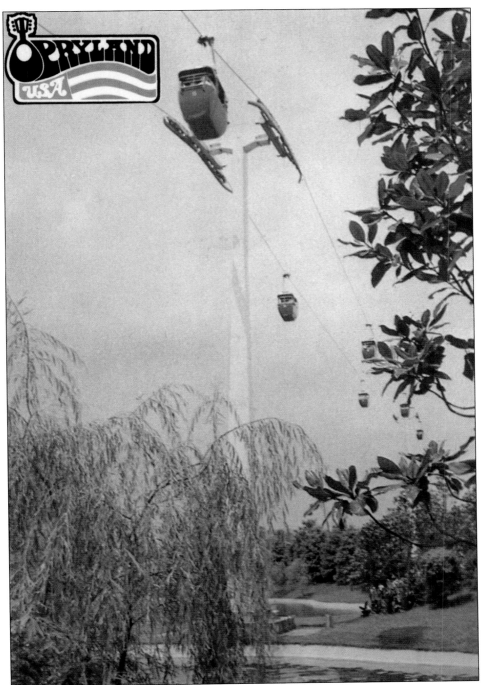

The number of cars operating on the ride was based on park attendance and determined by the area supervisor. The park's daily attendance projection would determine if there would be either 15, 20, 25, 30, or 35 cars on the loop. There was a strict limit of four guests per car. Late in the day, as the crowds dwindled, operations would make the call to pull cars out of rotation. Mod/Do Wah Ditty City would usually pull three while New Orleans would pull two.

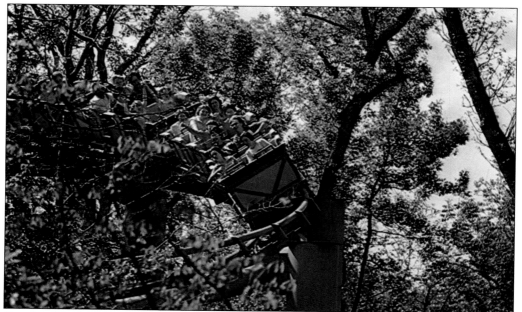

Opryland's only thrill ride when it opened was the Timber Topper (later renamed Rock 'N Roller Coaster). It was a unique roller coaster from Arrow Development that had twists and turns through the park's trees without touching a branch. Guests might be moving toward a tree and suddenly swerve away as the ground dropped away below. The Timber Topper was the 11th tubular steel roller coaster ever constructed.

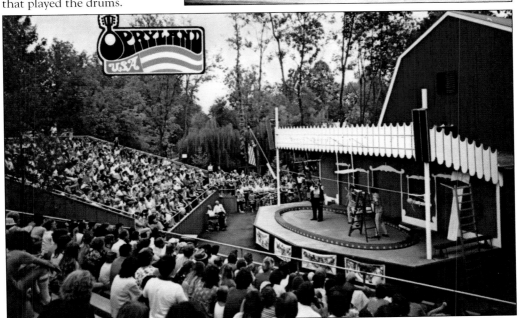

The "Animal Opry," originally conceived as part of Opryland's never-built Family area, was eventually constructed between the Music of Today and the American West. Later named "Animal Circus," the production included Madam Patricia, a world-famous dancing goat; Maggie, the baby elephant; guitar picking geese; a piano-playing pig; a cow that played a cellblock harmonica; and a duck named Burt Bachaquack that played the drums.

Shows were not limited to strictly adults. Theaters were built specially for the smaller set as well. From clowns to the "Billy Boy Beagle" puppet show, there was enough entertainment for the young and the old.

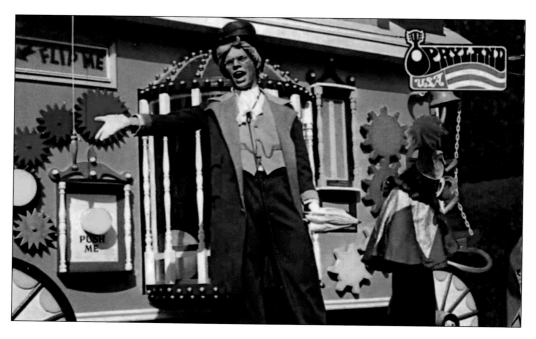

# *Three*

# COME SHARE
# THE WONDER

Opryland's genuine mix of rides, shows, and hospitality was never unnoticed. In fact, it was this blend of family entertainment that won the park the Applause Award, a biannual theme park honor that goes to a park whose "management, operations and creative accomplishments have inspired the industry with their foresight, originality and sound business development." The Magic Kingdom in Walt Disney World was the first park to win the coveted award in 1980. Opryland USA was the second park to win this proud accomplishment. (Nick Archer.)

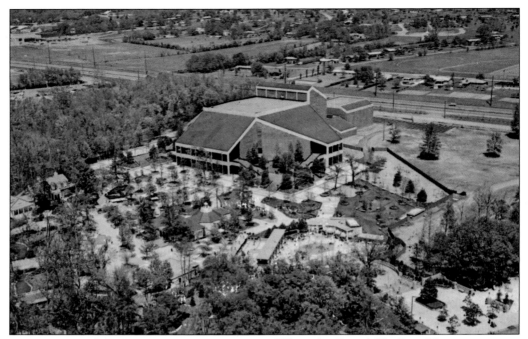

When the Grand Ole Opry House opened in March 1974, it not only gave Opryland visitors another show for the park, it also provided an additional venue for productions. Prior to moving to the Opryland complex, the Grand Ole Opry was produced on Friday nights and twice on Saturday nights, with occasional matinees as demand warranted. Once the park opened, the Opry could now play to the thousands of additional guests visiting the park with as many as eight performances each week. Additionally, during the days without a scheduled Opry performance, members of the Grand Ole Opry, such as Roy Acuff, Barbara Mandrell, Marty Robbins (shown at left), or Hank Snow, would perform a free hour long showcase in the Opry House.

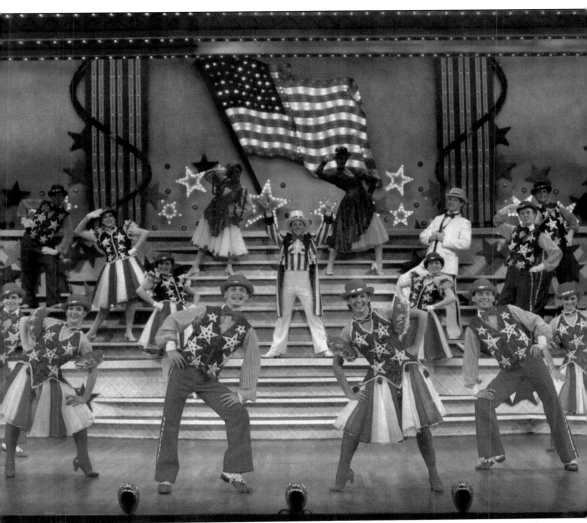

As Opryland grew in popularity, locations for future productions were in short supply, even with the use of the new Grand Ole Opry House as a site for shows during the day. The Gaslight Theatre was an open-air facility specifically built for *Me and My Gal*, a patriotic salute to the music of George M. Cohan. The show, which opened on May 9, 1977, had "Cohan" and his family and friends take the audience through a younger, more innocent America with the music from the 1890s to World War I. With a cast of 18 and an orchestra of 16, the show moved venues more than any other—from the Gaslight Theatre, to the American Music Theatre, and ultimately revived in the Acuff Theatre in 1993. When *I Hear America Singing*, *Showboat*, and *Me and My Gal* were all concurrently playing in the park, more than 100 years of American popular music could be experienced.

Unlike other show venues in the park, the Gaslight Theatre was built more like a soundstage. Once *Me and My Gal* had wrapped for the day, the theater could be used for different functions. For instance, during some years, Opryland guests could show off their own talent and dance until park closing. Live bands played seven nights a week. Big band music played Sunday through Thursday, 1950s music occurred on Fridays, and square dancing took over on Saturday night. In later years, the Gaslight Theatre was enclosed; and even later, it would become the home of Ralph Emery's *Nashville Now* show on The Nashville Network.

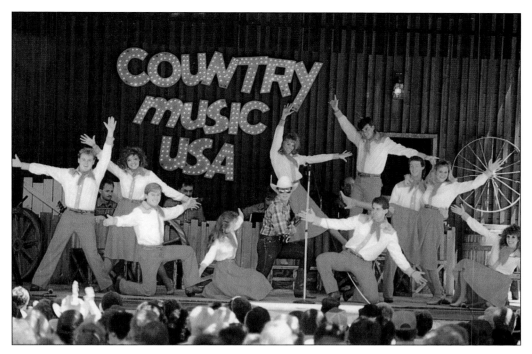

When the park first opened, if guests wanted to hear modern country, they could attend performances at a small wooden stage set up in the Lakeside area with a few scattered chairs. Then, in 1973, the Theatre by the Lake was built and became home to *Country Music USA*, a show that traced the history of country music and paid tribute to the stars that made it the most popular music around the world. Each year, the show was updated with current stars and their songs. The theater was shaded by trees and built in the style of an old gristmill. *Country Music USA* had several cast albums produced and even toured the Soviet Union in 1974. In 2009, it was brought back as a three-hour adaptation aboard the *General Jackson* showboat with original cast members who had played in the park's production.

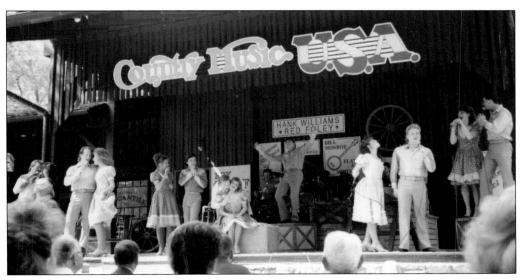

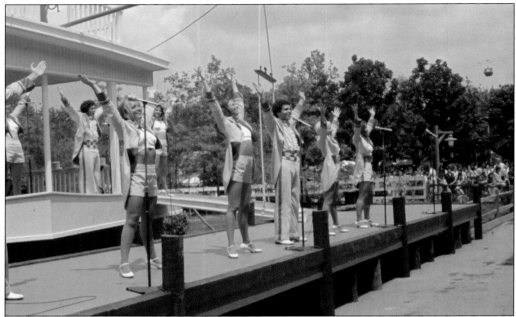

Once the park's plan for daily horse pageants failed to satisfy guests, the large arena built for the show was transformed into the Showboat Theatre in 1974. Each year, a different *Showboat* salute (*Showboat '74*, *Showboat '75*, etc.) would feature famous song-and-dance entertainers. A "cargo" of full-costumed singers and dancers performed a lively blend of riverboat jazz that spanned the musical spectrum from Mark Twain's day, to Judy Garland, to current hits. The show, like most other original park shows, was directed by Paul Crabtree. Opryland guests were now able to experience a delightful riverside show from the days of riverboat floating palaces. The showboat performances and setting wet the appetite of park executives and inspired the construction of an authentic showboat and a real floating palace.

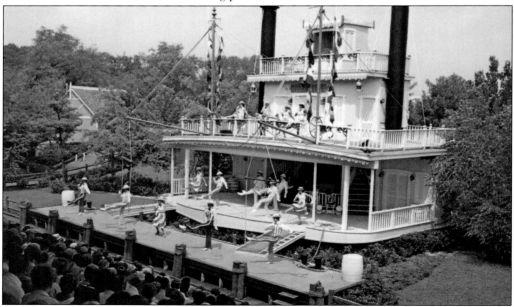

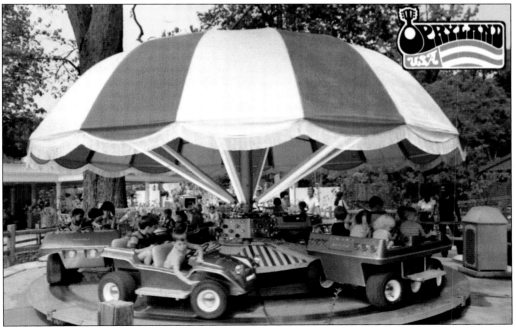

Opryland was severely lacking in activities for children when it first opened in 1972. Consequently, an entire section was developed just for the younger set. Hostesses in alpine costumes welcomed youngsters to an area with rides like the Red Baron Airplanes, Tiny Timber Topper, Dune Buggies, Mini Mill, and the Surry with the Fringe on Top. Although the names of the attractions changed over the years, the rides did not.

The Tiny Timber Topper—which would also go by the names Mini Rock 'n Roller Coaster and Sharp's Shooters—was originally built in 1960 by the Allan Herschell Company in North Tonawanda, New York. Labeled the Little Dipper model, it consisted of one train with three cars, accommodating four people per car.

The Red Baron Airplanes, later known as Pee Wee Pilots, was a custom attraction based on the popular flying elephant ride found at other theme parks. Like the Tiny Timber Topper, Red Baron Airplanes was also built by the Allan Herschell Company. (Michael Parham.)

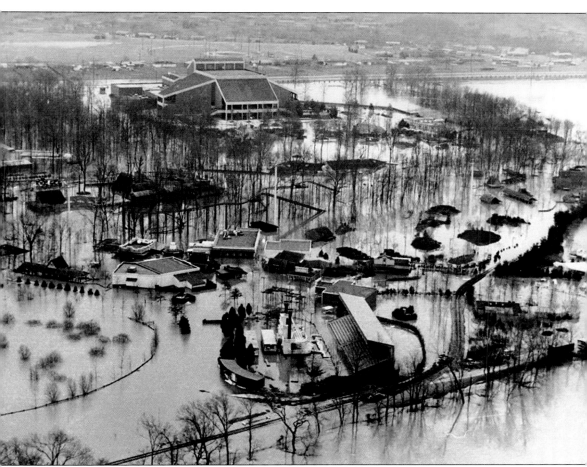

On March 14, 1975, after 15 days of heavy rain, the nearby Cumberland River overflowed the protective wall built to protect the park. Opryland was flooded with as much as 16 feet of water. The park was scheduled to open just days later on March 29. More than 2.5 inches of rain had fallen during the week prior. The Petting Zoo lost 2 wolves, 5 goats, 6 rabbits, 13 quails, and few bantam chickens. The park's bison and deer were moved to a higher field, and the chimpanzees were sent home with Opryland's zoo employees. Maggie, the park's baby elephant, was housed in the Grand Ole Opry's prop room. The damage estimate came to over $5 million. (TENN.)

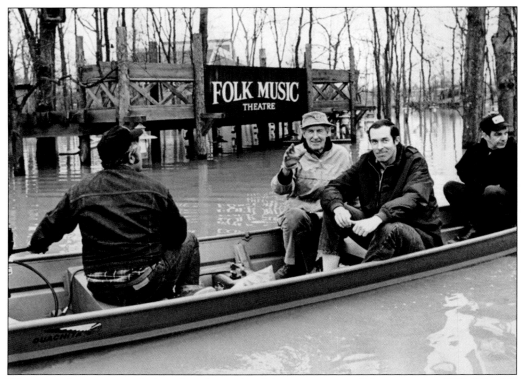

There was intense speculation that the park might not open until late summer. E.W. Wendell said, "I guarantee you that we will be open this spring. I know the damage will be extensive, but I've seen floods. We will open this spring. We'll throw every contractor we can find on that dude and have it going in no time." Opryland was able to open on April 19, 1975, after a tent sale in the parking lot that sold flood-damaged goods to the public. Some items were caked with dried mud, while others were only slightly damp. Over 6,000 people attended the sale. After the park reopened, the flood wall was enhanced. (Above, Ed Stone; below, TENN.)

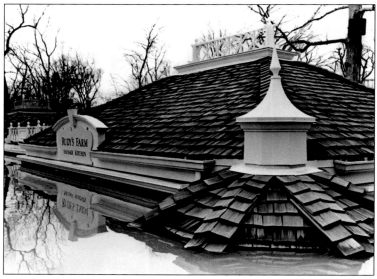

Once the new Opry House was complete, plans were immediately laid for a second $2 million, 1,500-seat theater adjacent to the Opry. The Acuff Theatre was originally available to independent bookers and promoters. Ultimately, it found itself home to park productions and up-charged performances. It had a proscenium, individual theater seating, a lobby, full orchestra pit, the latest lighting systems, and sufficient wing and backstage space to handle large shows. In 1979, the first year it was open, the Acuff Theatre was sometimes home to three shows a day, including the "Cosmic Laser Explosion" light show.

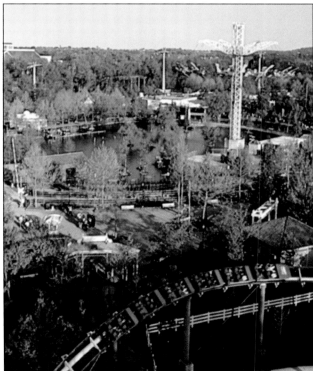

Just two weeks before the 1975 flood, Opryland announced a $2.5 million expansion project to add seven additional acres with nine new buildings, a new themed area, and a major ride attraction. Later that year, the State Fair area opened on the north side of the park, with the Wabash Cannonball roller coaster and assorted games. Other attractions soon followed. The Country Bumpkin bumper cars soon followed with 50 two-person cars specially designed for Opryland to resemble Model A Fords.

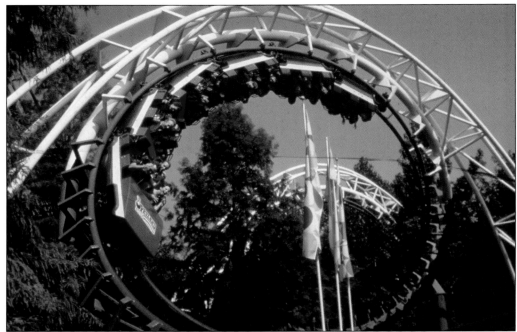

Named after the famous Roy Acuff song, the Wabash Cannonball was a standard double corkscrew roller coaster built by Arrow Development. The company built 14 of these models (10 are still in operation as of 2016). The Wabash Cannonball was one of the first three built in 1975. There were two six-car trains that held up to 24 passengers each. The trains would climb the lift hill 70 feet in the air before traveling the 1,200-foot-long track at speeds up to 50 miles per hour. (Above, Opry Entertainment; below, Nick Archer.)

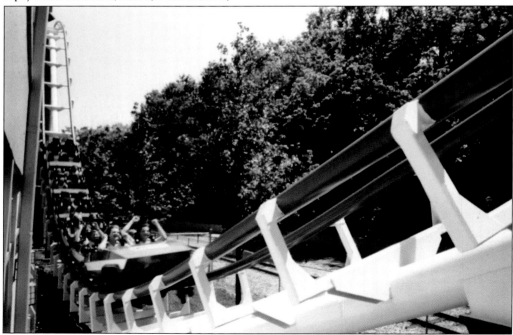

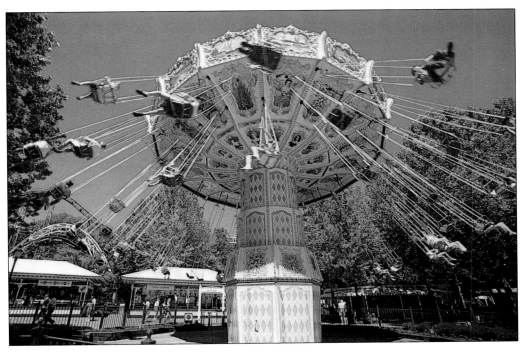

The Tennessee Waltz wave swinger ride, installed in 1977, was named after the Tennessee state song of the same name, with lyrics by Redd Stewart and music by Grand Ole Opry member Pee Wee King. As the music started, the center column rose and rotated as the riders were lifted to a height of approximately of 42 feet as the title song played in the background.

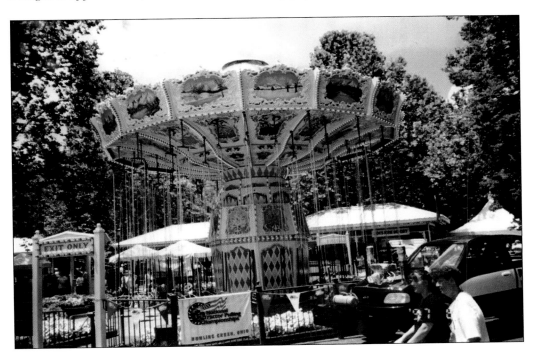

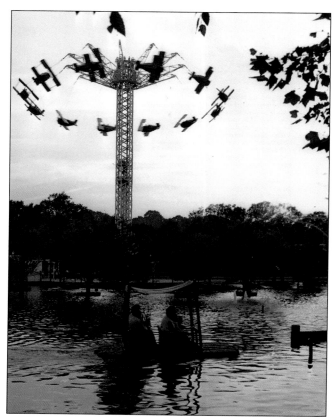

Built in 1978, the Barnstormer was a 100-foot tower at the edge of Eagle Lake that took guests on an aerial voyage around the State Fair and Lakeside areas of Opryland. Twelve World War I–themed biplanes hydraulically ascended up a steel column, each with up to four passengers. With 10 rotations per minute, the attraction generated 1.8 g-force at the top. The cables holding the planes would then extend, creating a free-falling flying effect as the planes returned to earth. The ride was manufactured by Bradley and Kaye of Long Beach, California. Very few were built, and none are still standing. Unfortunately, if the wind was ever above 15 miles per hour, the ride would close. Consequently, the Barnstormer sat idle roughly half of the operating year due to winds off the Cumberland River.

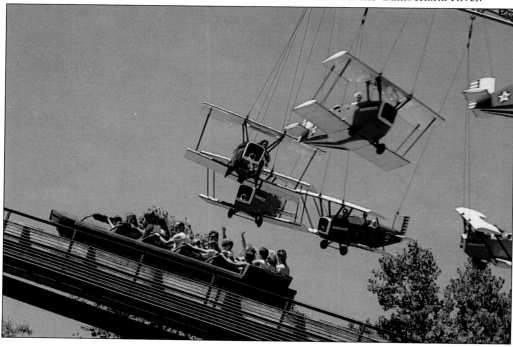

In 1978, a $250,000 floral extravaganza called Riverside Gardens was erected on the banks of the Cumberland River where the wild Animal Ravine once stood. Opryland's horticulture specialists gathered and planted an explosion of flowers that was as fragrant as it was beautiful. After experiencing the color and beauty of the gardens, visitors could visit the Riverside Gardens Shop, which was stocked with potted plants, baskets, and other "flora-phernalia." Ultimately, Opryland guests did not enjoy carrying souvenir flowers and plants with them throughout the day. The Riverside Gardens only survived a few years, and the Riverside Gardens Shop began selling generic park merchandise. (Both, author's collection.)

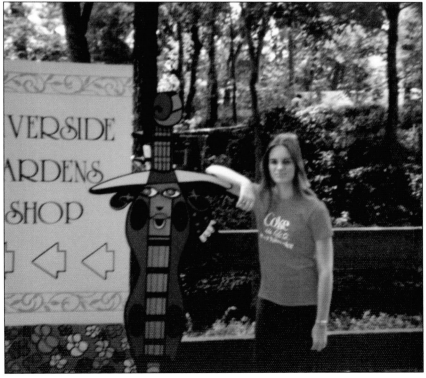

Even with the Riverside kids' area attracting children to its wondrous rides, Opryland was still short on children's activities. In 1979, additional amusements were built. Directly across from the American Music Theatre, the Kids Stuff land was an enchanting assortment of rides, activities, and entertainment. Children could wiggle through the Ball Crawl, try out the Balance Beam, climb a challenging path to the King of the Mountain, or pilot the Yachts of Fun. Like the Lakeside kids' area, these attractions would have different names throughout their life, but most would survive until the park's closure in 1997. (Both, author's collection.)

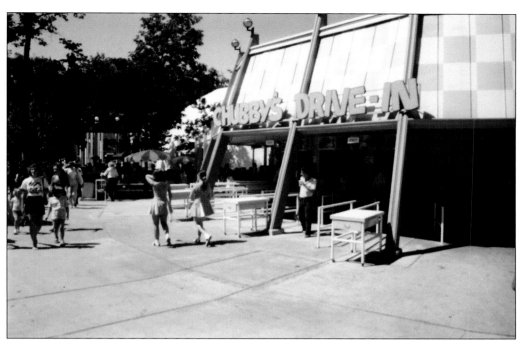

Having a region of the park that was so ultra-modern, like the Music of Today area, it was destined to eventually fade into obscurity. The Mod era was fading just as the 1970s were coming to a close. In order to prevent a refurbished Mod scene from falling out of fashion in the 1980s, park designers looked to the nifty 1950s, and Do Wah Ditty City was born. The Hamburger Pavilion became Chubby's Drive-In. The Pizza Parlor was converted to Julio's Pizza, the Stable Rock Theatre became the Juke Box Theatre, and the Music of Today Theatre turned into the Flip Side Theatre. With two theaters, back to back, the park was able to produce shows with shared resources and a combined 2,200 seats. The Juke Box and Flip Side Theatres closed in 1990 for the construction of the Chevrolet Geo Theater. More than 25,000 shows had been produced in the 18 years they existed in Opryland, with over 14.5 million guests experiencing their musical spectacles. (Above, Nick Archer; right, Opry Entertainment.)

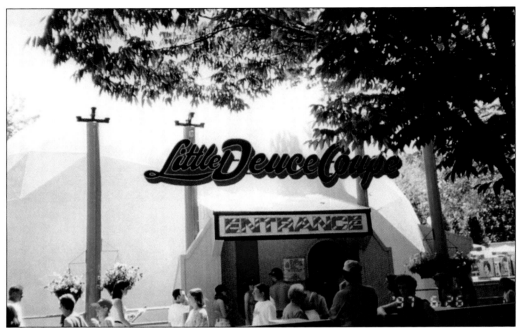

With the arrival of Do Wah Ditty City, the former Disc Jockey drunken barrel attraction became the Little Deuce Coupe. The attraction, named after a popular Beach Boys' song, was enclosed in a geodesic dome. As the ride began, strobe lights, fog machines, and music began to play as the ride spun to the tunes of the 1950s.

# *Four*

# AMERICA'S MUSICAL SHOWPLACE

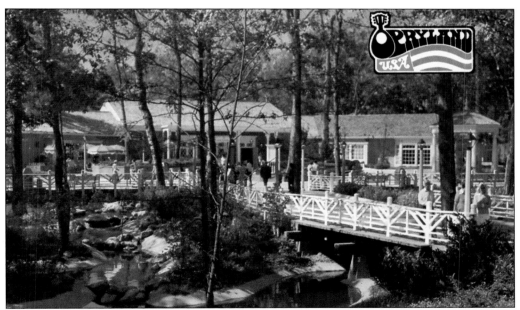

As the 1970s transitioned into the 1980s, country music entered the national zeitgeist, and Opryland was at its heart. In fact, it was at Opryland's Acuff Theatre that Barbara Mandrell recorded "I Was Country When Country Wasn't Cool." With each new theater and ride that was added, there were supplemental restaurants and shops built to accommodate the increased capacity. But unlike regional parks serving only hamburgers and hot dogs, Opryland catered to all tastes. Restaurants offered everything from prime rib to guitar-shaped ice cream on a stick.

There were 21 eating facilities when the park opened. By 1997, there were over 30. Opryland even had a version of Disney's popular character meals. In later years, groups of 12 or more could have breakfast with a member of the Grand Ole Opry, such as Jim Ed Brown, Jeanne Pruett, or Little Jimmy Dickens.

In 1982, Opryland's restaurants went through 70,350 pounds of popcorn, 65,832 pounds of Kahn's brand hot dogs, 224,515 pounds of French fries, 114,000 pounds of hamburger meat, and 4,755,150 Coca-Cola products. In order to prepare all of that food, the laundry washed 4,500 kitchen towels every day.

The shops and boutiques at Opryland sold more than just branded souvenir T-shirts and hats. For example, the Hill Country area featured stores that sold handmade items like candles, rare musical instruments, woodcut pieces, and stained glass. Elsewhere in the park, one could get Christmas items, Western wear, personalized leatherwork, blown glass, totem pole paintings, and more.

The New Orleans area was especially popular with shoppers. The Gallerie Royale Gift Shop, a building that resembles an aged New Orleans manor house, was beside the Collector's Corner. This unique shop featured nonstandard theme park fare, such as one-of-a-kind antique curios and true collectibles.

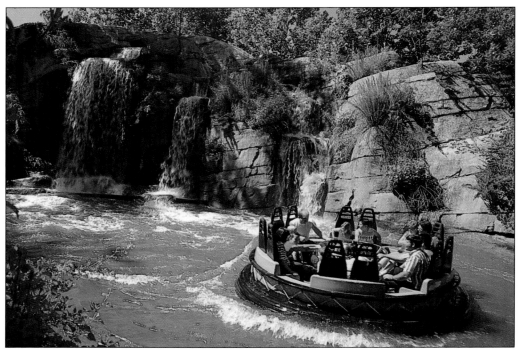

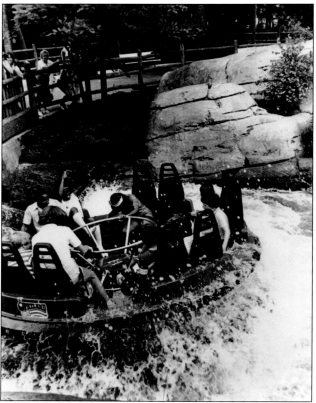

Opryland USA celebrated its 10th anniversary in 1981. To commemorate the event, the park spent $4.7 million to build the Grizzly River Rampage rapids ride. This type of attraction, from Intamin, had been introduced the year before at Six Flags AstroWorld. Opryland's version was one of the three built the next year. The Grizzly River Rampage covered 10 acres with a path that was almost a quarter of a mile. Water for the river was supplied by a local well. Man-made rock work and artificial boulders were sculpted by John DeSantis for Rock & Waterscape Systems. Floating rafts drifted down the course without guides, beside waterfalls, and through a 270-foot-long cave with an animatronic grizzly bear.

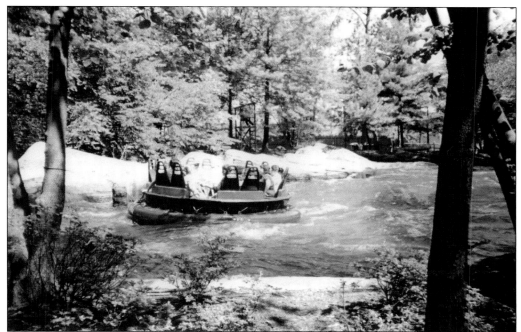

The Grizzly River Rampage was reportedly one of Roy Acuff's favorite attractions in the park. During the ride's opening weekend, Dan Taggerty, star of television's *Grizzly Adams*, greeted guests and signed autographs. Over 100 attraction names were considered before Grizzly River Rampage was locked in as the final choice. Designers searched for a country music connection. Options were Whiskey River or Red River Valley, both taken from song titles, or even the Ernest Tubbs. The river was registered as class III rapids. On September 16, in the run-up to the 1996 Summer Olympics in Atlanta, the Grizzly River Rampage was home to the 1995 US Kayak Championship, a preliminary matchup to the Whitewater Slalom Competition at Tennessee's Ocoee River.

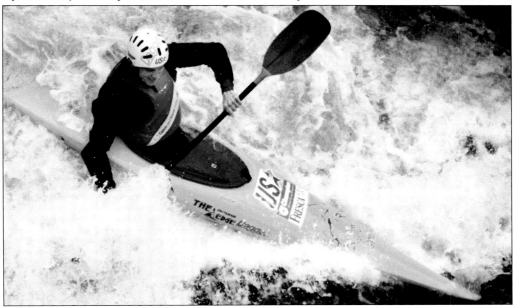

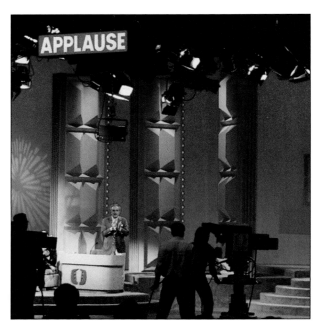

Years before Universal Studios Florida or the Disney/MGM Studios offered guests a look behind the scenes of television and movie production, Opryland USA was home to live, daily television tapings on its own cable channel. The Nashville Network launched on March 7, 1983, with daily tapings of *Nashville Now* in the park. It was a live 90-minute variety show that featured music, comedy segments, and celebrity interviews that were hosted by Ralph Emery on Monday through Friday nights. The Nashville Network was essentially an added attraction for park guests. On any given day, visitors could be in the audience for exclusive concerts, game shows, dance shows, and cooking specials.

Edward L. Gaylord takes the stage of the Grand Ole Opry to announce that Oklahoma Publishing Company has purchased Opryland. By 1979, National Life and Accident Insurance Company, Opryland's corporate owner, was under attack by American General, Charter Oil, and Seagram's (future owner of Universal Parks). Ultimately, American General paid $1.5 billion for the company and promptly put the Opryland properties up for sale. Several suitors lined up to buy either the entire Opryland package or only select elements. Interested parties included US Tobacco, future Opryland Hotel manager Marriott International, and a consortium of local Nashville investors led by Benson and Martha Ingram.

It was Grand Ole Opry member Minnie Pearl that convinced the owner of the Oklahoma Publishing Company, Edward L Gaylord, to buy the entire Opryland assets for $250 million. Gaylord was the producer of *Hee Haw*, a television variety show that featured most of the Grand Ole Opry stars. On September 1, 1983, the deal became final. Gaylord kept E.W. Wendell and other leaders in their existing key roles in the newly created company, Opryland USA, Inc. After Gaylord purchased the properties, $150 million was spent in expansion projects in just the first five years.

After the death of Mildred Acuff and the murder of David "Stringbean" Akeman following a Grand Ole Opry performance, Roy Acuff began to worry about living alone in his house on Moss Rose Drive. When a few Opryland executives jokingly mentioned to Roy that he should move into E.W. Wendell's office above the Roy Acuff Music Hall, Wendell offered to build Acuff his own house just outside the park. Acuff accepted by saying, "I'm leading a very lonely life in a big house all by myself. Now, I'll be someplace where there'll be people. I want to straighten out my life. It'll help to get me out of this loneliness I live in. I'm in the park or the Opry House every day anyway. I realize that with millions of people visiting Opryland, some will want to drop in on me at the house. It isn't going to bother me." (TENN.)

The house was finished in March 1982 when Roy Acuff was 79 years old. Although located several yards away, on paper the house was technically an addition to the Roy Acuff Music Hall. It had two bedrooms, a bath, a kitchen, a basement garage, and an attic to store additional career-related memorabilia that Acuff had accumulated. It remained property of the park. After Acuff passed away in 1992, it was left vacant for a number of years before being renovated for corporate offices. Steve Buchanan, president of Opry Entertainment, worked out of the house for several years. (Author's collection.)

Construction on the Screamin' Delta Demon began in November 1983 for a 1984 opening. It was a gigantic serpentine chute above the marshy area once home to Riverside Gardens and Animal Ravine. Six stories high and built by Intamin of Switzerland, this $3.7 million attraction was the first of its kind to be constructed. The ride's layout covered approximately two acres and was built around existing sidewalks and bridges that linked New Orleans to a special group admissions gate. All other parks that erected this type of attraction used the Screamin' Delta Demon's custom layout. Six Flags had the model on a ride rotation program and noticed a flaw in the braking system. When they reconstructed the attraction at different parks, they modified the break run to eliminate unnecessary deceleration. Consequently, their attractions' vehicles traveled faster, with riders generally experiencing a more favorably adventure. The Screamin' Delta Demon's track was never altered.

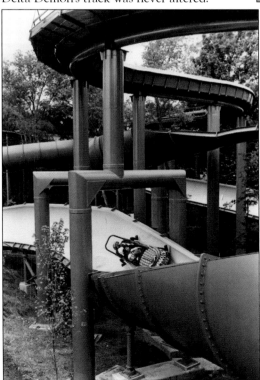

The Screamin' Delta Demon's grand opening featured a dramatic production and story with actor Richard Cowl playing a swamp hermit in an equally elaborate themed setting for the attraction. The queue to the station was filled with shacks, buoys and lanterns. Overhead, the ride vehicles literally "screamed" as they rolled through the 12-foot-wide chute. The wheels to the attraction were made of a compound that was temperature sensitive—soft in the heat and hard in the cold. Consequently, the vehicles always traveled faster when it was cool, maxing out at 40 miles per hour.

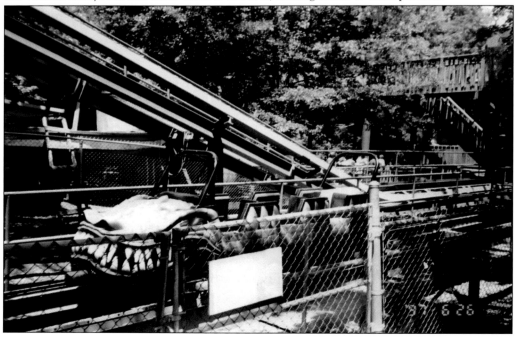

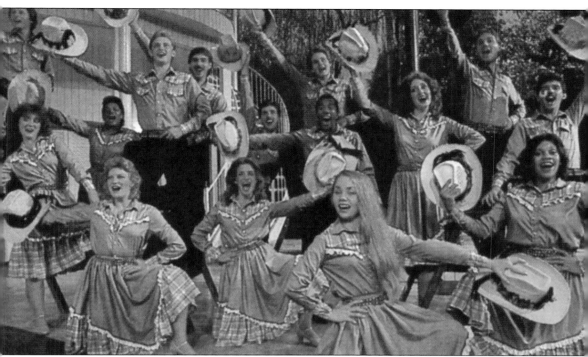

Opryland exported its choreographers, writers, directors, and musicians to perform a show entitled *Sing Tennessee* for the Tennessee pavilion at the Knoxville World's Fair in 1982. Afterwards, the musical returned to the park for a one-year run in the outdoor Showboat Theatre, renamed the Tennessee Music Theatre. The performance, the longest in the park's history, ran for two hours, retelling the state's musical heritage with actors performing as Roy Acuff, Brenda Lee, Dina Shore, Pat Boone, and others.

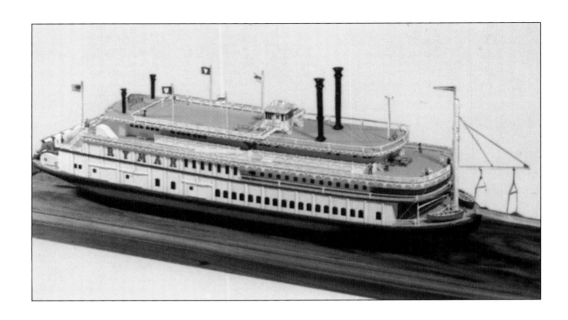

On July 2, 1985, a $12 million paddle wheel showboat was launched as an additional attraction to cruise the Cumberland River. The vessel was christened the *General Jackson* by Thelma Gaylord in ceremonies at Nashville's Riverfront Park. Originally to be called the *Ryman*, the *General Jackson* was designed by Nickum Spaulding Associates of Seattle, Washington, and built by Jeffboat, LLC of Jefferson, Indiana. As of 2016, the *General Jackson* may cruise up to seven times per week; however, during Opryland's peak in the 1980s and 1990s, it would travel from Opryland to downtown as many as four times per day. Additionally, it would make special seasonal trips to Old Hickory Lake, as seen below.

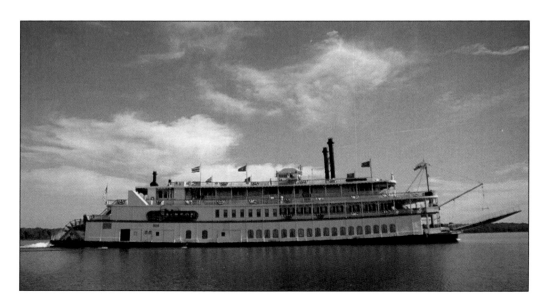

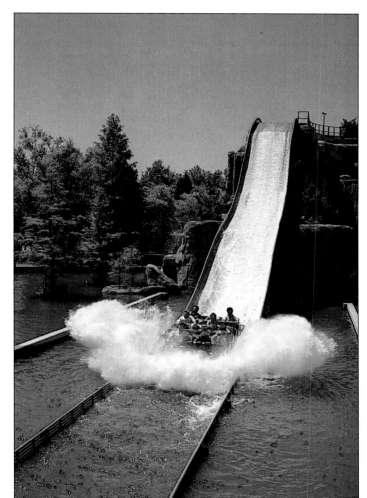

Opryland's third water ride, Old Mill Scream, opened in 1987. Dominating the three-acre Eagle-Lake, the attraction consisted of a giant 60-foot-tall man-made mountain with four 20-passenger boats floating down a 50-foot-long double-dipped waterfall into the lake below with a gigantic splash waiting for both the riders and bystanders.

The Old Mill Scream was manufactured by Intamin at a cost of $2.6 million and could accommodate over 1,800 guests per hour. From the point the boats left the gristmill loading station and returned, they traveled over 1,200 feet.

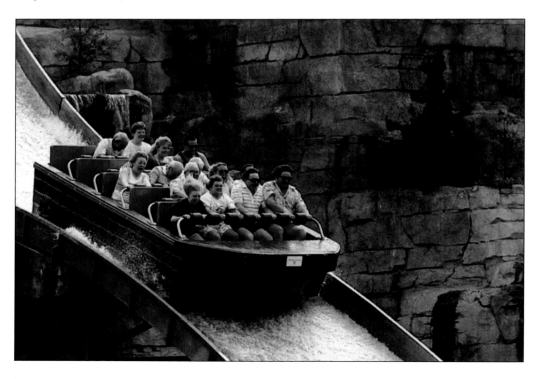

*Way Out West* transformed the Showboat Theatre once again when that show moved into the amphitheater in 1987. Now referred to as the El Paso Theatre, it was home to this new musical, a light-hearted show set in the Old West, featuring music from American cowboys, Broadway, television, and movies. The show also included comedy scenes like a barroom brawl, a bank robbery, and a gunfight. The finale was a celebration with songs by famous cowboy singers like Gene Autry, Earnest Tubb, and Marty Robbins.

The show *Music, Music, Music* first opened in the Acuff Theatre as an up-charged ensemble show outside the park. The 75-minute production was full of 38 performers described as "3 rings of entertainment." In 1988, Rock and Roll Hall of Fame and Country Music Hall of Fame member Brenda Lee joined the cast with 16 songs, 15 production numbers, and 7 costume changes.

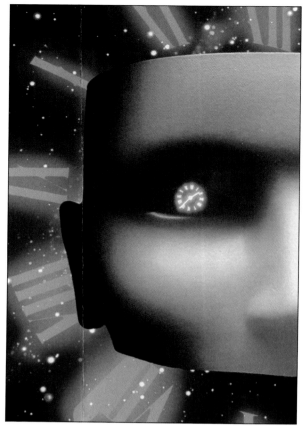

In 1989, the park undertook the single largest project in the property's history—the construction of CHAOS, a $7 million indoor roller coaster. It was described as a first-of-its-kind thrill-ride hybrid that combined "shattering glass, grinding gears, roaring flames, weird man-in-the-moon images, a clock gone haywire, and a train that roars along seemingly out of control" all via 70-mm film and a 40-car coaster train, the longest roller coaster train in the world (a record that still stands). The ride was built by Dutch attraction manufacturer Vekoma and opened on March 25, 1989. A grand opening was held on April 8, 1989, with an appearance by actor Corey Feldman. Most indoor roller coasters and the buildings that enclose them are two different structures. However, the CHAOS building was a covering attached to the coaster's outer framework. (Left, Opry Entertainment; below, author's collection.)

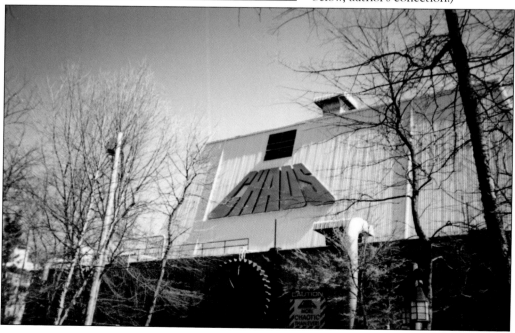

*Five*

# THE MOST FUN
# IN THE COUNTRY

By the 1990s, the Opryland theme park, which had transitioned to the unique "Opryland Themepark" designation, was only a small cog in Gaylord's large Opryland USA machine. There were now multiple cable networks, a golf course, river taxis, downtown Nashville destinations, a second theme park in San Antonio, and the Opryland Hotel, now the largest hotel in the world under one roof. Back in the 1960s, when the idea of Opryland was first hatched, the empire consisted of just the Grand Ole Opry and WSM.

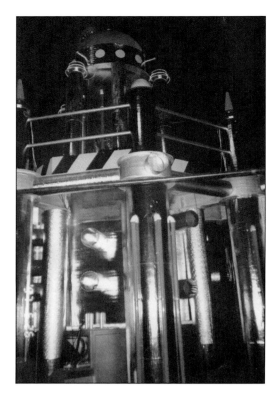

From the moment it was installed, CHAOS was regularly updated. In 1990, the park added spectrum diffraction glasses. In 1991, CHAOS became the first roller coaster to play synchronized music when the attraction added Michael Hoenig's electronic music track "Bones on the Beach" to the ride. In 1994, CHAOS was refurbished again. The large 70-mm screens were gone, and two new showpieces were added: a large two-story nuclear reactor, built on the floor of the structure, and an animatronic dragon, which appeared to lurch out at guests as the coaster train zoomed by.

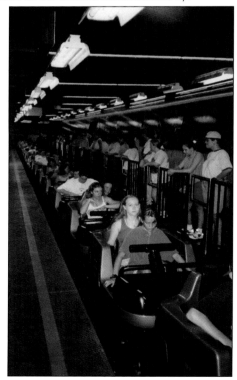

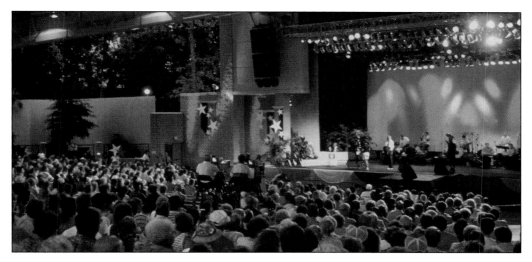

Opryland's research showed that 17 percent of visitors came to the park just to see the stars, and 26 percent were senior citizens. Consequently, management steered away from their successful formula of building new rides and attractions every other year. Instead the park invested in "Nashville On Stage," a 150-night concert series that brought big-name country music stars into the park every night the park was open. To handle the crowds that would attend the concerts, Opryland would eventually build the Chevrolet/GEO Celebrity Theater, a $2 million, 3,500-seat amphitheater that had covered seating for 2,300.

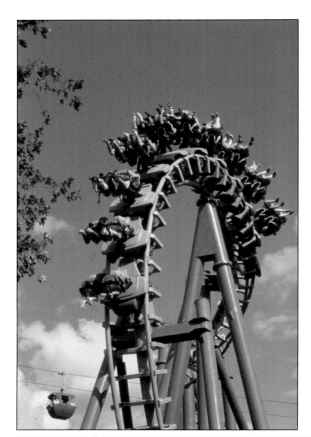

When Opryland announced the arrival of their latest attraction in February 1995, they struck the perfect chord of country and western theming with their choice of the inverted roller coaster, the Hangman. A total of $8 million was spent on the Vekoma-brand roller coaster, site preparation, and theming. Construction began in fall of 1994. Visitors to the "Christmas in the Park" event were able to preview the ride and even sit in two coaster cars without knowing the ride's name or logo.

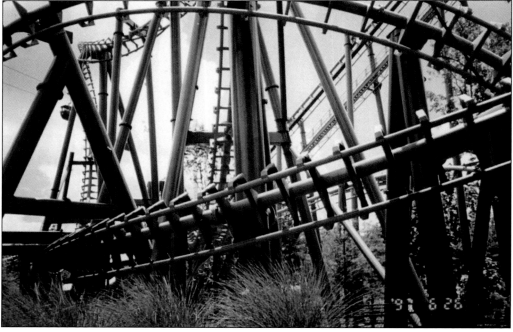

The Hangman was noted as one of the smoother models of this type of roller coaster, but it was plagued with technical problems. Guests were stranded during a power outage in 1996. Then, on July 8 1997, eight people were trapped when the train stalled just beyond the lift hill as a piece of plastic was caught in the lift chain. It took firefighters six hours to rescue the guests. Afterward, a special carriage to rescue passengers was added to the track should this ever occur again.

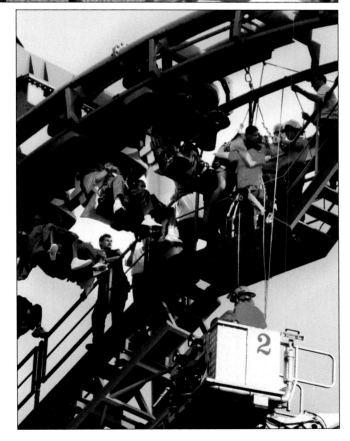

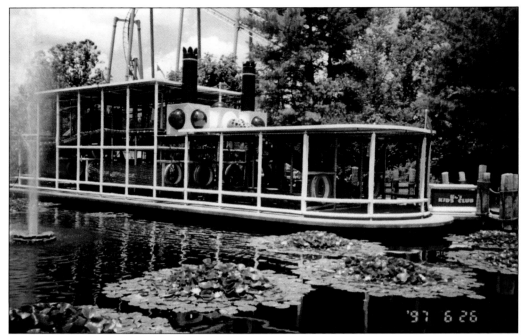

The park's Riverside kids' area was renovated with a new playground, a replica of the *General Jackson* showboat. New children's rides like the Convoy and Tykes Tugboats were also added to the area. In addition, new Kids Club characters and an associated children's theater were introduced to tie the land together.

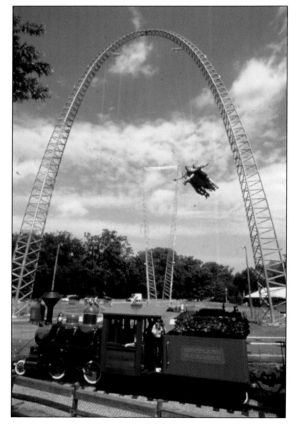

To add to the thrills, Opryland built a Skycoaster. One to three riders were carried to the top of a launch tower and then dropped towards the ground, swinging from a cable back and forth until they reached the platform. Opryland's Skycoaster was 173 feet high (twice as high as the Skyride). The attraction was originally in the State Fair area. Later, the up-charged attraction moved to Lakeside for better visibility.

# *Six*

# A CIRCLE BROKEN

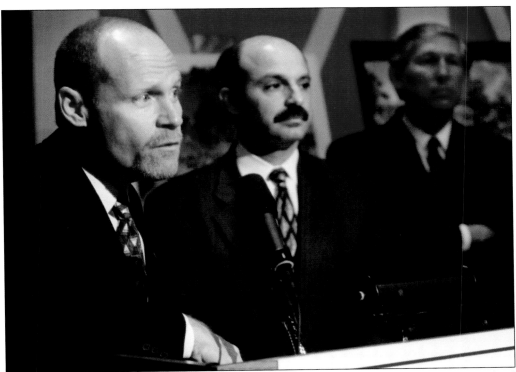

Contrary to popular belief, Opryland USA theme park always made money—even during its final years. However, due to the increasing popularity of the Opryland Hotel and a new management team led by Terry London, executives within Gaylord Entertainment felt that the property adjacent to the hotel could be better monetized if it were less of a seasonal attraction. CEO Larry Siegel (left) and Steve Jacobsen (center), senior vice president of the Mills Corporations, answer questions about Opryland Themepark's transformation with Terry London (right) from the stage of the Grand Ole Opry on November 4, 1997. (TENN.)

It was announced that Opryland Themepark would close for two years in order to undergo a retail makeover into what executives called "Destination Opryland." The new mixed-used development would include dockside nightclubs and restaurants alongside the *General Jackson*'s marina, where a fireworks celebration and street party would occur each night; a broadcast center with studio tours of TNN, CMT, and other network facilities; a redeveloped Grand Ole Opry with a new exterior, a new stage design, and new standard seating, which would replace the Opry's traditional pews; approximately two-thirds of the existing Opryland Themepark would remain and include existing rides or shows as well as areas reserved for future attractions; and, finally, an outlet mall, called Opry Mills. An entertainment corridor in the mall was designed to link together all of the new areas with existing facilities. Terry London, Gaylord Entertainment's CEO, even stated during the Destination Opryland press conference that it was not the end of Opryland Themepark; however, weeks before the announcement, 13 of the most popular rides had been quietly put up for auction. (Michael Parham.)

Premier Parks was a moderately sized theme park company founded in Oklahoma in 1982. In 1997, they purchased 13 of Opryland's rides for $7,034,000. In 1998, Premier purchased the Six Flags theme park chain and assumed their identity. (Author's collection.)

The rides were dismantled during the 1997 "Christmas in the Park" event. They were prepared for shipment to Indiana, where the rides were scheduled to be part of Premier's plan to rebuild Old Indiana Fun Park, a defunct park near Indianapolis. Old Indiana was closed in 1996 after a four year old was paralyzed during a ride accident. After the purchase of Six Flags, Premier cancelled their plans for Indiana and refocused their priorities. The company began to use the former Old Indiana park as a storage site for the entire chain. Some of the Opryland rides were moved to Six Flags parks while others remained in an Indiana field, slowly rusting away. The Hangman became Kong at Six Flags Discovery Kingdom in California, the Rock 'N Roller Coaster became Canyon Blaster at Six Flags Great Escape in New York, and the Old Mill Scream was moved to Wild Waves Theme Park in Washington. Attractions like CHAOS, Wabash Cannonball, the Flume Zoom and the Screamin' Delta Demon were simply sold for scrap metal. (Above, author's collection; below, TENN.)

During the final weeks of operation, giant tents were erected in the parking lot to sell Opryland USA merchandise that would never be restocked. Additionally, signs from rides and shows were made available so visiting park guests could purchase a piece of Opryland to take home.

On December 31, 1997, Opryland USA theme park closed forever. Opry Mills was completed in 2000. The mall, which was drastically different from what was originally proposed, was the only element of the Destination Opryland concept to open. A few years later, after Gaylord had sold their interest in Opry Mills at a loss, the new CEO admitted the company had made a mistake in closing the park.

Gaylord Entertainment, once the largest private employer in the state of Tennessee, now has little more than 200 employees. In 2012, the company transitioned from being an entertainment and hospitality company into a real estate trust. The company, now known as Ryman Hospitality, still manages the Grand Ole Opry, WSM, and the Ryman Auditorium. Very little of the former park is left onsite. Garbage cans from Opryland, seen above, dot the walkway from the Grand Ole Opry to the Gaylord Opryland Resort, now managed by Marriott International. The original group sales building was moved to the *General Jackson* dock. Planned to be part of the Cumberland Landing district that never materialized, the building now sits empty. Located behind the Gaylord Opryland Events Center, a small concrete wall remains from CHAOS.

# DISCOVER THOUSANDS OF LOCAL HISTORY BOOKS
## FEATURING MILLIONS OF VINTAGE IMAGES

Arcadia Publishing, the leading local history publisher in the United States, is committed to making history accessible and meaningful through publishing books that celebrate and preserve the heritage of America's people and places.

## Find more books like this at
## www.arcadiapublishing.com

Search for your hometown history, your old
stomping grounds, and even your favorite sports team.

Consistent with our mission to preserve history on a local level, this book was printed in South Carolina on American-made paper and manufactured entirely in the United States. Products carrying the accredited Forest Stewardship Council (FSC) label are printed on 100 percent FSC-certified paper.